PAINT REPRESENTS EXPERIENCE
AND MAKES IT ACTUAL

PETER LANYON

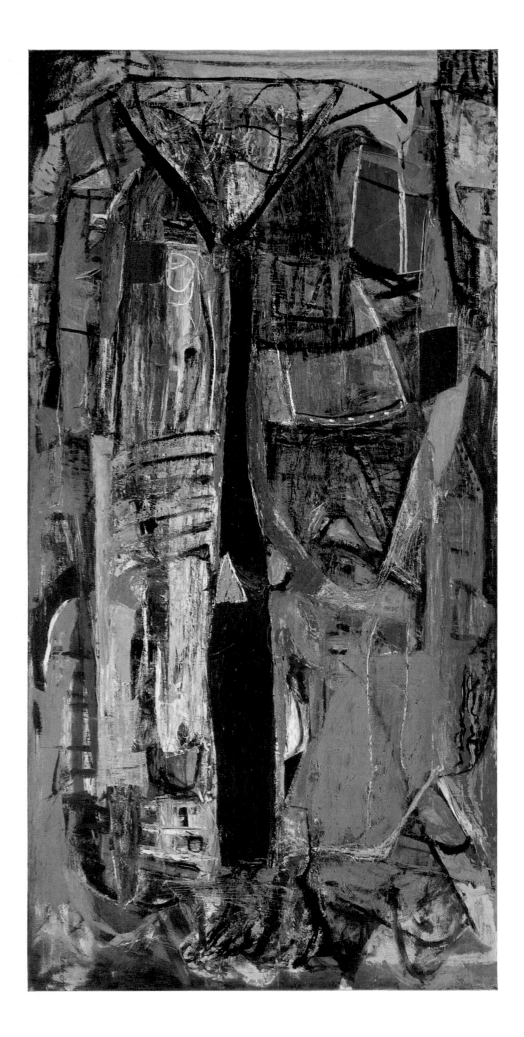

Plate 1

St Just

PETER LANYON

HIS PAINTING BY ANDREW CAUSEY

WITH AN INTRODUCTION BY NAUM GABO

AIDAN ELLIS PUBLISHING LIMITED — ENGLAND

I am grateful to Alan Bowness for his advice, and for letting me use his tape-recordings of conversations with the artist; to Patrick Heron for help on points of detail; to Patrick Hayman for allowing me to quote extensively from the *Painter and Sculptor*; to the directors of Gimpel Fils and other owners of Lanyon's paintings who have supplied me with information. Most of all, I am indebted to Sheila Lanyon for making personal records available and for her continuous assistance during the preparation of the book.

A.C.

The publisher also wishes to thank Basil Jacobs Fine Art Ltd., representing the Estate of Peter Lanyon, for their assistance in the publication of the book, and the British Council and the directors of Gimpel Fils for the loan of their blocks; thanks also go to Sheila Lanyon, without whose help the book would not have been possible, and to the collectors who gave their permission for the reproduction and photographing of their works.

Published in Great Britain in 1971 by:

Aidan Ellis Publishing Limited
Cobb House
Nuffield
Henley-on-Thames
Oxon. RG9 5RU
England

SBN 85628 000 3
Printed and bound by Lund Humphries, Bradford

Letterpress four-colour blocks and black and white blocks by
Gilchrist Bros. Ltd, Leeds

CONTENTS

INTRODUCTION *by*

NAUM GABO

I knew Peter since the very beginning of the Second
World War, 1939.

I remember him arriving at my studio with a portfolio
in response to my invitation after I met him with
friends in Carbis Bay. Looking through his sketches
and paintings, the very first few attracted my
attention so strongly that I did not really need, later,
to look at the rest so attentively. I call them
'sketches' — but these were the kind of sketches which
are, by the finality of their expression, saying more of
the artist's world than the most elaborate paintings.
The way the volumes, the surfaces and the lines, the
inside world of the objects, were treated in the
sketches told me that before me was a young but
already accomplished artist. Already in these sketches
his vision was manifestly abstract in its approach
to the world, though naturalistically rendered. He
very soon found himself entirely at home in the
abstract world, which he used in his painting only
as a means to convey his vision of the naturalistic
world.

It is unfortunate that very soon he, like many others of his generation, had to go to war. He stayed away long enough to mature both in life and in art, but he did not lose his artistic energy and the clarity of his vision.

On his return he threw himself into his work and never tired of investigating new paths, and he kept in his later work the high quality of his colours and the soundness of the composition in his painting. It must be deplored that accident should break up an artist's life in the very hey-day of his creative ability.

My attraction to Peter never terminated. During all the later years he was fast developing and remained devoted to the abstract ideas, remaining all the time himself and never falling into the trap of repeating what had already been done by others, but constantly going ahead. What he has done remains, and to me it is obvious that it will serve as an excellent example of both the achievements and the tribulations of the young generation of artists of our time.

The Painting of

PETER LANYON

by

ANDREW CAUSEY

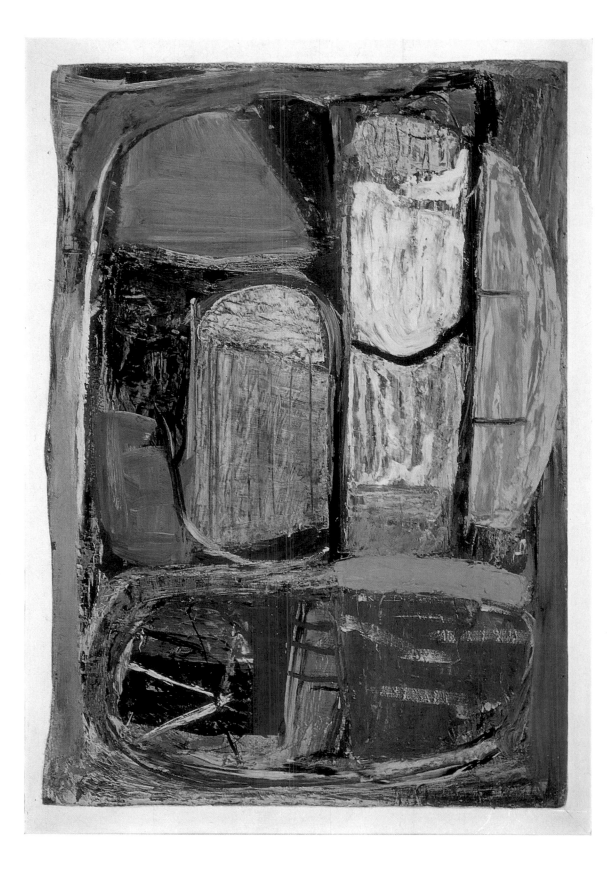

Plate 2

Farm Backs

Peter Lanyon used to speak of his childhood in St Ives, of driving in the car with his father round the undulating coast road from St Ives to Land's End, and discovering in that furthest tip of Cornwall the places that were to be the source of inspiration for his painting. Westwards from St Ives the road curls through the treeless hillsides with grey granite boulders thrown up among the bracken. The sea is below to the right, and the road, as it rises and falls and curves with the contours of the hills, seems to mediate between the liquid and amorphous blues of the sea and sky on one side, and the greens, greys and occasional licheny yellow of the moorland rising on the other. For Lanyon it grew to be a sequence of encounters between himself and nature, and between the natural elements themselves: the soft springy grass against the fat grey stones, the cool blue-grey of the sky against the brighter and more luminous blue of the sea and, fundamental to his sense of the animation of the scene, the endless motion of the sea against the rocks. 'I paint the weather and high places and the places where solids and fluids meet. The junction of sea and cliff, wind and cliff, the human body and places all contribute to this concern.'[1]

As a boy Lanyon used to meet the local artists in their studios. He remembered that the first picture to excite him was a painting of bluebells by Lamorna Birch in which the paint was so rich that he expected it actually to smell of bluebells. His innate pleasure in the texture and feel of paint developed into a command of its use that has been surprisingly rare among English artists. Lanyon came to understand that the application of paint to a flat surface demands of the artist obedience to certain internal laws with which the visual subject must accord.

The character of each of his subjects pervades his pictures, but without dominating them. He insisted he was a landscape painter not an abstractionist, but his landscapes are imbued with a rootedly abstract quality. He extracted the energy from places with which he had a personal rapport, and in his paintings offered his experiences back in a form which he hoped would help to extend consciousness of the meanings of nature and its configurations in the landscape of western Cornwall.

Lanyon was born at St Ives in 1918 and lived there, apart from years away at boarding school and on war service, till his death in 1964. His parents were talented musically; his father was a composer and pianist, as well as an amateur photographer. A man of wide interests, he used to open his home to his friends on Sunday evenings for discussion of the arts and philosophy. He sent his son to school at Clifton College where the music master, Douglas Fox, was his friend. Peter Lanyon learned the piano, preferring to play his own improvisations to the work of the well-known composers. Music was a pleasure for him, but his discipline was to be drawing. He had gained the feeling of a reality close to hand, a sense of the live presence of the landscape surrounding and pressing in on him. So when he decided in 1936 to go to art school, he naturally chose the local one at Penzance. He was already taking lessons with Borlase Smart, a Cornish painter whose example deeply impressed him. He described Smart as a marvellous draughtsman and a tough, correct, no-nonsense character who loved the cliffs and the open coast. Smart concentrated Lanyon's attention on the solidity of the granite rocks and the rhythm of the waves' repeated battering against the cliffs; art school training involved drawing from casts of antique sculptures, which Lanyon was less fond of. In 1937 Lanyon was discovered by Adrian Stokes, the writer on art and aesthetics, who directed him to the Euston Road school of

art in London. Lanyon was not particularly happy there, and stayed for only four months; but the training had a lasting impression. The slow methodical procedure taught by William Coldstream involved building up the picture from an accretion of small marks out of which the images gradually developed. Lanyon was not won over by the form of realist painting associated with the school, but first learned there a more logical and less agitated technique.

When he left London in 1938 Lanyon was doing landscapes which were already distinguished by the confident handling of the paint. They were dependent on Cézanne, whose native Provençal countryside Lanyon visited in the summer of that year. But he was conscious of a growing discontent with treating what was immediately in front of him, and was beginning to find his emotional involvement with the landscape stronger than his ability to translate this commitment into paint. 'When I began to paint, the cliff edge and winter storms put more pressure on me than I could absorb. My pictures became so wild, messy and dispersed that I was driven indoors and I settled for experiments in the technical problems of painting.'

In 1939 Adrian Stokes introduced Lanyon to Ben Nicholson and Naum Gabo who had recently settled in St Ives. Nicholson became his teacher for two sessions a week, and helped him towards a simpler form of expression, setting up groups of objects to see what Lanyon could make of them in formal, plastic terms. The example of Nicholson's own work – in particular the completely abstract white reliefs – and the rigour of his teaching, relaxed for the moment Lanyon's allegiance to his local environment, and the change was confirmed by Gabo, the artist Lanyon most admired at the time and continued to respect long after their work had diverged. The experiments Lanyon carried out under the influence of Gabo and Nicholson were relief constructions like **White Track** (1939–40), *Plate 25*: 'I wanted to find out how to reproduce the weight of things. The object was to reduce the heaviness of the wood in the centre by the use of dynamic elements. A white dish shape is held by a sling on the diagonal, and a red cylindrical form travels round a white track. These two elements make the whole construction light and dynamic instead of heavy and static.' Lanyon was learning ways of describing space, movement and energy in visual terms. **White Track,** gave him real, tangible materials to explore without prior commitment to any idea.

From 1940 to 1945 Lanyon served with the R.A.F. in North Africa, Palestine and Italy. He suffered from migraine which made it impossible for him to become a pilot as he would have liked. Flying, which he was to take up seriously in 1959, appealed to him because he wanted the fullest possible experience of his surroundings. The dangers of war, the need for constant awareness of sound and movement on all sides, increased his sense of circumscription, of being part of an environment that is equally alive on all sides, to which vision alone, operating in only one direction at once, cannot do justice. From 1944 he was able to do a few paintings, **Ruins at Capua** (1945), *Plate 3*, being perhaps the best of the wartime pictures. It is a strange painting in blues, greens and golden browns, influenced perhaps by the Italian metaphysical painters like Giorgio de Chirico.

Back in Cornwall after the war Lanyon married and started a family. A series of paintings begun in 1946 concerns generation, a theme he developed in most cases through a connection with

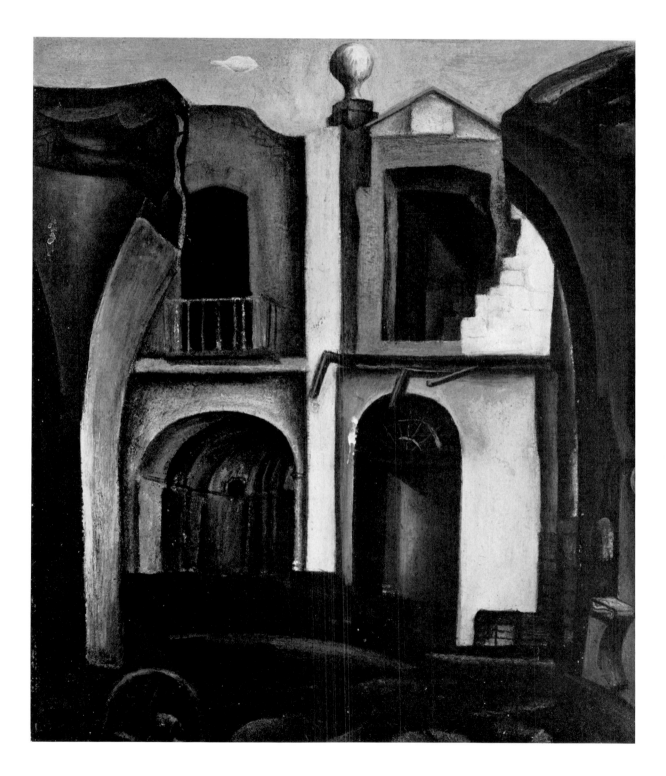

Plate 3

Ruins at Capua

Plate 4 **Tinstone**

Plate 5 **Landscape with Cup (Annunciation)**

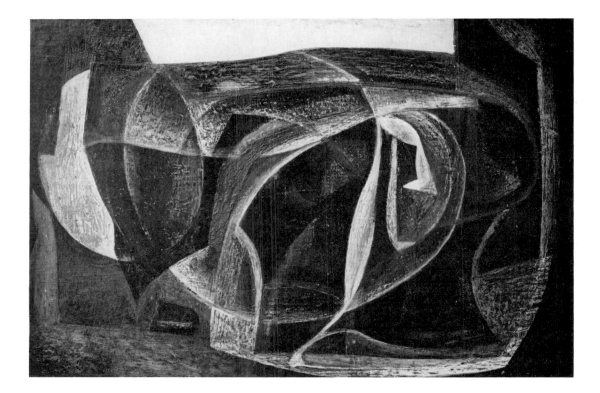

Plate 6 **Construction in Green**

Plate 7 **Prelude**

Plate 8

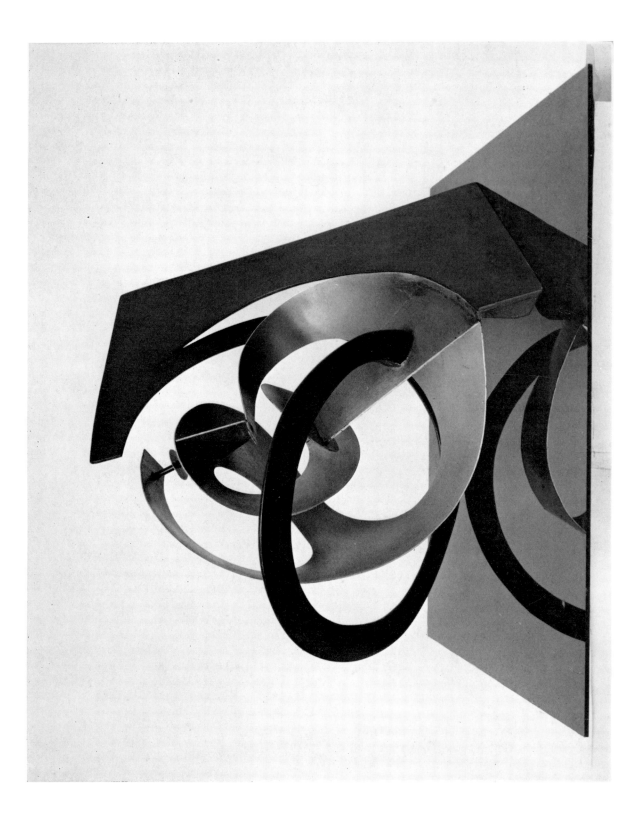

Construction

Plate 9

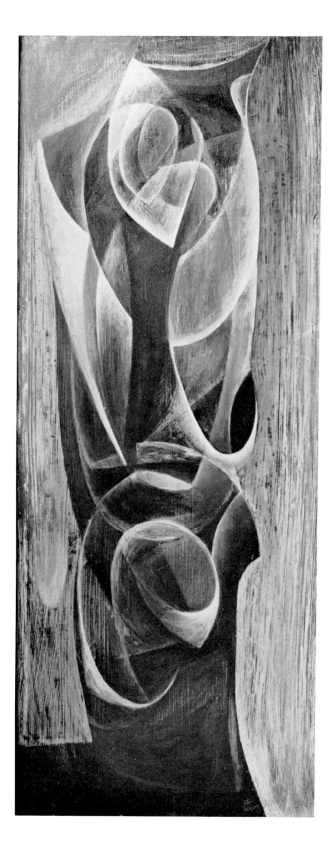

Plate 10 **Generation**

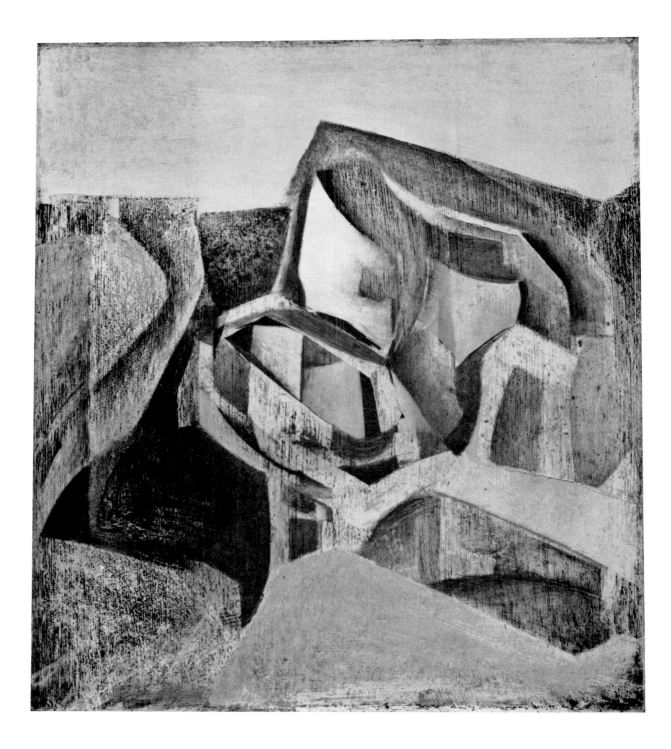

Plate 11 **Portreath**

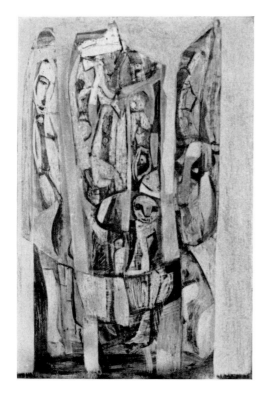

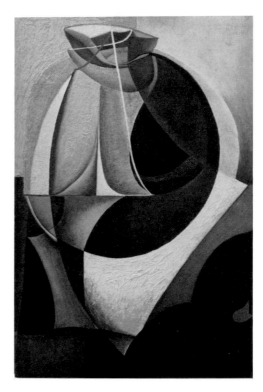

Plate 12 **Cape Family**

Plate 13 **Generator**

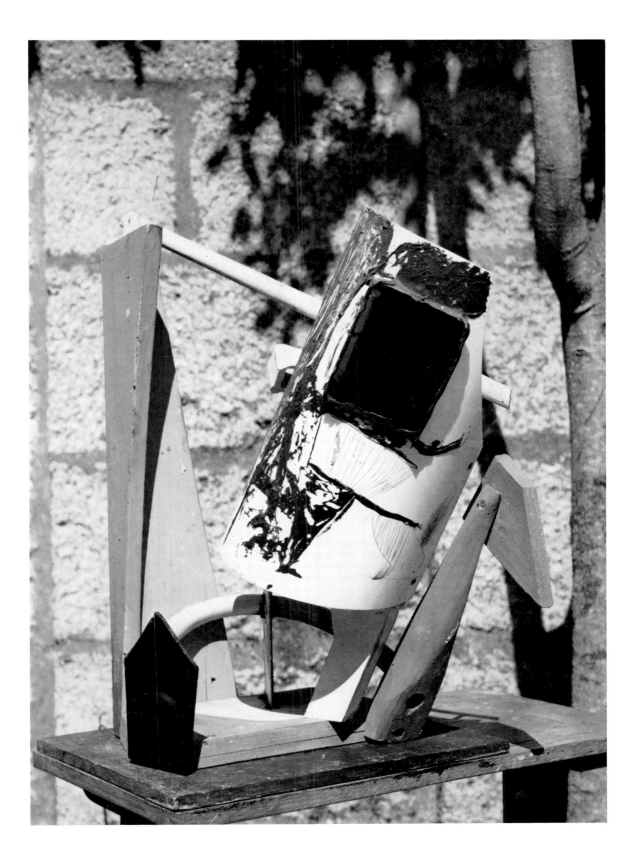

Plate 14

Construction for Bojewyan

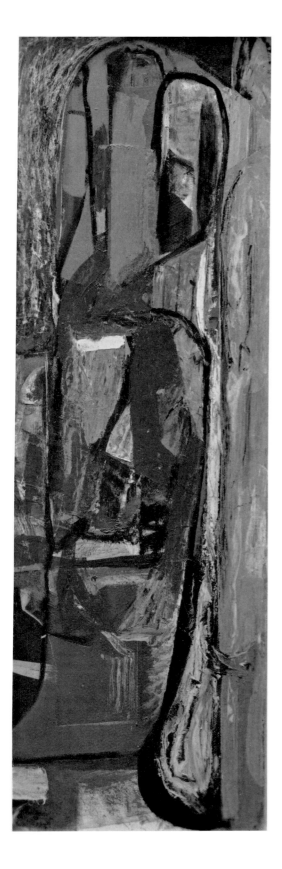

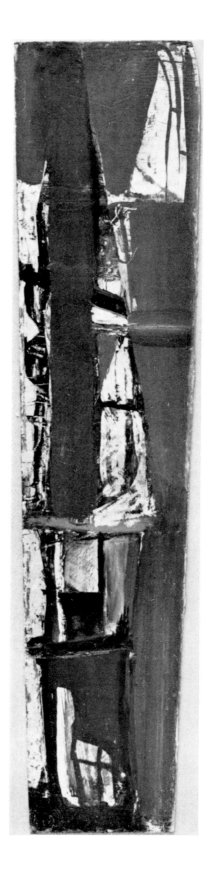

Plate 15

Harvest Festival

Plate 16

Corsham Towers

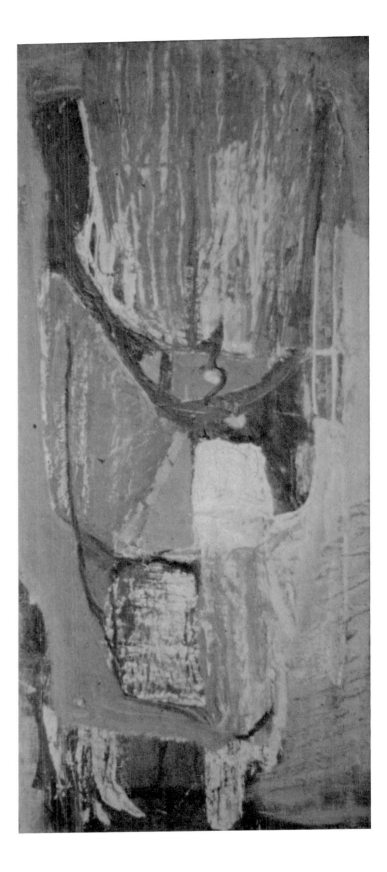

Plate 17 **Cape Wind**

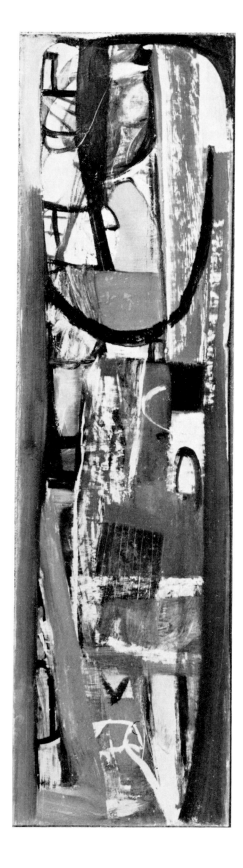

Plate 18 **Botallack**

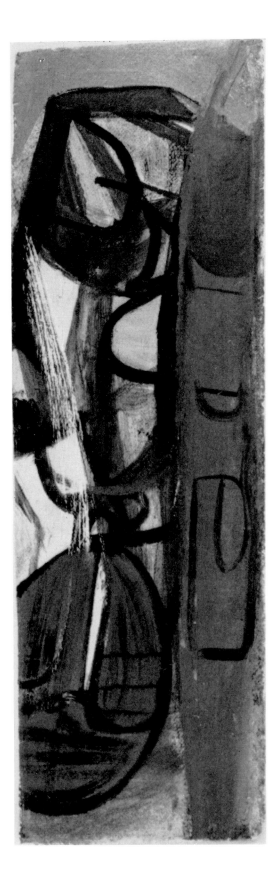

Plate 19

Bicyclist in Penwith

Plate 20

Corsham Summer

Plate 21 **Moor Cliff, Kynance**

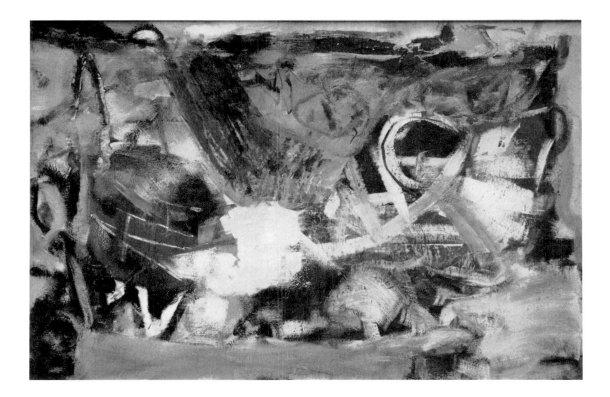

Plate 22 **St Ives Bay**

Plate 23 **Isle of Purbeck**

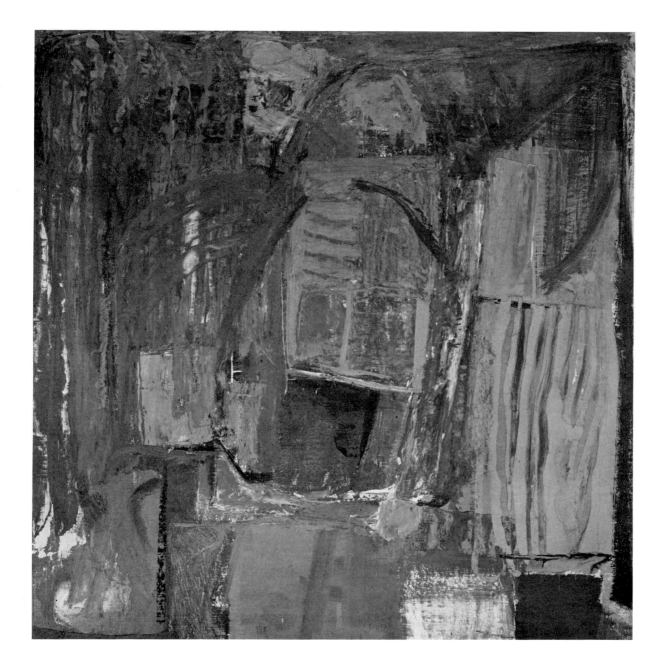

Plate 24 **Primavera**

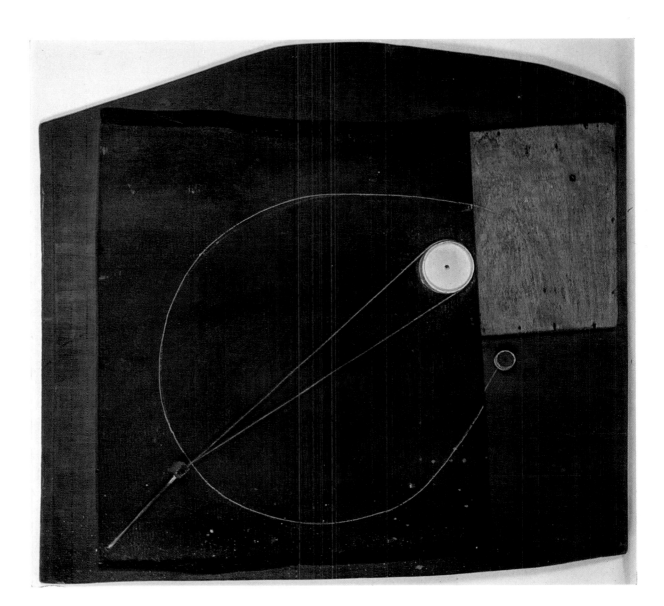

Plate 25

White Track

landscape. After a long period abroad, frequently in hostile surroundings, Lanyon naturally reverted to his identification with the landscape to which he belonged and which, after a time of worry and uncertainty, must have reassured him through its permanence and familiarity. A number of pictures in the next few years, like **Tinstone** (1947), *Plate 4*, are completely abstract, but most of Lanyon's painting reflects the almost universal move in English painting away from abstraction which, since 1939, had guided even Nicholson back to a partially representational form of art.

The picture Lanyon particularly associated with his homecoming was **The Yellow Runner** (1946), *Plate 26*. The setting was the hills above Gunwalloe on the Lizard. A yellow horse travels at great speed across a distant hillside on the left; in the foreground a semi-abstract complex of forms, partly recognisable as a horse, seems to read as being beneath the ground; on the right there is a red field which Lanyon has turned into a fox by the addition of a bushy tail. Lanyon connected the central section with a womb or a stockade to which the yellow runner returns. He described it as a picture of fertility. It relates both to a moment in his own life and to the crystallisation of certain ideas in his mind about the character of landscape. As a landscape painting its mood corresponds with the state of his own mind. In his copy of Adrian Stokes's *Colour and Form*, which Lanyon treasured, he underlined the sentence: 'Art is the mirror of life, just because the creative process mirrors and concentrates the character common to all the processes of living, namely, the identification of inner states with specific objects, animate or inanimate, in the outside world, the conversion entailed when fantasy life is attached by the conscious mind to the world of reality.'[2]

Lanyon felt that landscape possessed a specifically feminine character as the mother and sustainer of natural life, and that the sea, pressing against and infiltrating the coastline, was a masculine element. This idea, which was to become a basic theme of his painting, is expressed here for the first time in the smooth curve of the wave merging into the headland on the left, and the same theme underlines the yellow runner's return home. The runner resembles a prehistoric hill carving like the Uffington white horse, which gives him a feeling of being far away in time, parallel to his actual distance in space.

Lanyon spoke of painting in terms of the way it could describe the history and character of a place surfacing. In using the image of the womb for the female element he was referring to the idea of underground mineral wealth which he saw as the counterpart of nature's richness. He was fascinated by the old mineshafts with their tall chimneys and the ruined housings of the winding gear which are dotted over western Cornwall, and looked upon them as signifying a kind of wealth or power coming to the surface. The twin ideas of returning and surfacing work together to suggest that the runner and the stockade, two elements now far apart, will draw together.

Colour was used symbolically in **The Yellow Runner**; red has connections with risk or danger, as it was to have again in the gliding pictures after 1959, while yellow has sexual connotations which Lanyon might have understood from *The Yellow Horse*, a painting with similar implications by Christopher Wood, whose art interested Lanyon. But colour is also logically

balanced to meet the requirements of the picture. Yellow and brightish green on the left strengthen the small forms in the distance; much of the larger foreground complex is more darkly coloured, while the strong red of the fox draws the eye across to the right. As a personal statement **The Yellow Runner,** *Plate 26,* carries absolute conviction. As a painting it is intriguing but unsteady, flawed by over-complexity in the central stockade image and incomplete success in drawing distance and foreground into the same pictorial organisation.

The next two pictures in the generation series are **Landscape with Cup (Annunciation)** (1946), *Plate 5,* and **Prelude** (1947), *Plate 7.* The first, with a goblet standing before a receding landscape, is reminiscent of Nicholson's work at the same time. **Prelude** continues the motif of the enclosed form of the stockade in **The Yellow Runner,** which also recurs in **Construction in Green** (1947), *Plate 6,* a more abstract painting dependent on the elaborate planar relationships of Gabo's sculpture. But this is recognisably the work of a painter, not a sculptor using paint, because the unity of the picture is established by the light which emerges from the body of the paint. Gabo's influence was still strong in 1947 as Lanyon's three-dimensional **Construction,** *Plate 8,* shows, but only one of his post-war paintings, **Generator** (1946), *Plate 13,* works in a sculptural way — as a complex of planar relationships — rather than in a painter's way through an overall unity of colour.

The culmination of the series was **Generation** (1947), *Plate 10,* again indebted to Gabo in the ways the forms are actually put together, but the overall image is that of an Italian Renaissance Virgin and Child. **Generation** is an elegant rather than a powerful painting, a hint perhaps that the theme was worked out. Lanyon's way forward was to be through landscape and not the figure.

The Yellow Boat (1948), *Plate 9,* shows a boat floating on a dark pool with a smooth hillock beyond. The images are more self-contained than in **The Yellow Runner,** but the two share that sense of a mysterious underground activity, as if the boat and the pool were within the earth and the bulging hillock the outward manifestation of some enclosed vitality. The presentation is simpler than in **The Yellow Runner** and there is less sense of narrative: a debt, perhaps, to Nicholson. The way in which each part of the picture seems to be studied separately recalls the individual surfaces of the construction **White Track,** *Plate 25.*

By the time Lanyon started **Portreath** (1949), *Plate 11,* he was certainly thinking back to his pre-war abstract experiments. 'It is a very frontal picture with planes looking at you, and it might almost have been made in a square box. For me, the picture is a direct portrait of a place — the Cornish fishing village of Portreath. There is a pier that runs round the edge of a very steep cliff, and the curious blue shape is the way that the water forms round the bottom of the cliff. The rock at Portreath is all slate, and slate tends to come away in big, flat planes, and I use these throughout the picture. You might say that the place is an excuse for me to construct a square picture with planes working in depth and on the surface. The little red square is more of a device to hold the forms in place, but in fact it derives from a red brick building down on the dock.'

Lanyon here makes a serious attack on the problem of perspective diminution, attempting to break the conventional relationships of things in the distance as seen by the eye, and instead to

Plate 26

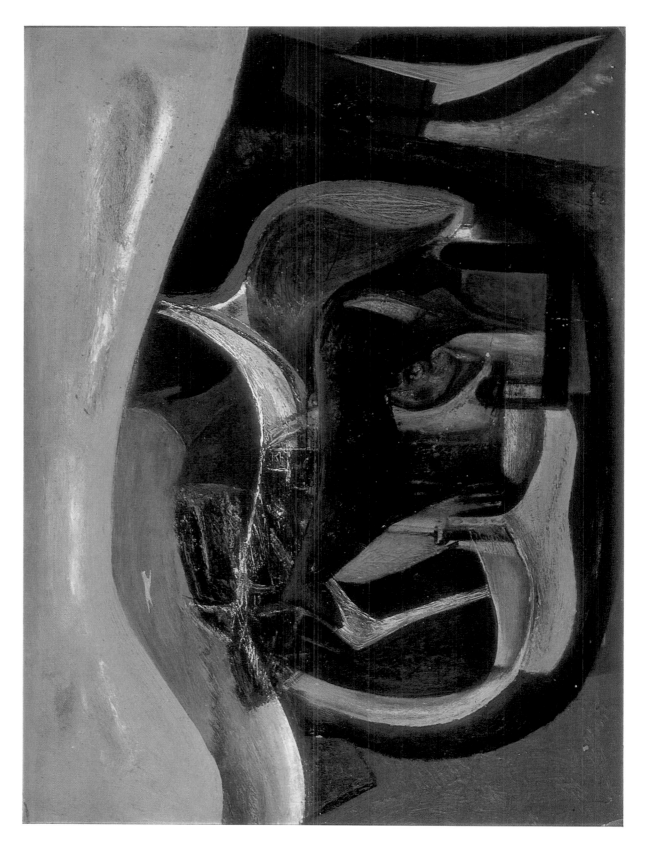

The Yellow Runner

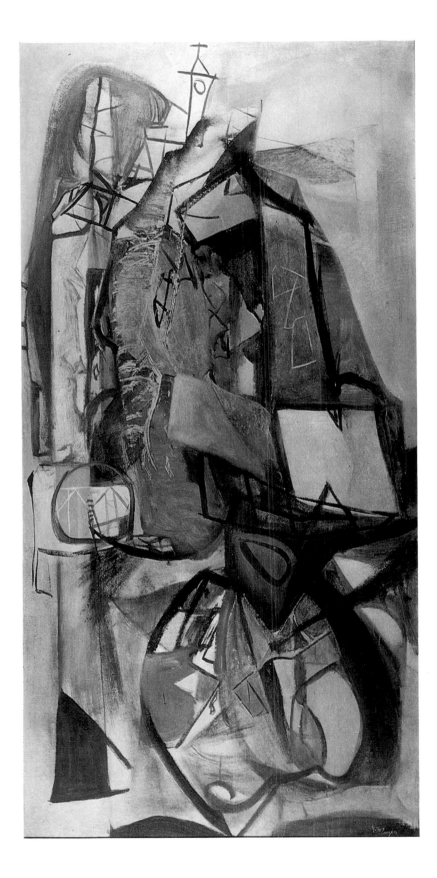

Plate 27 **Porthleven**

Plate 28

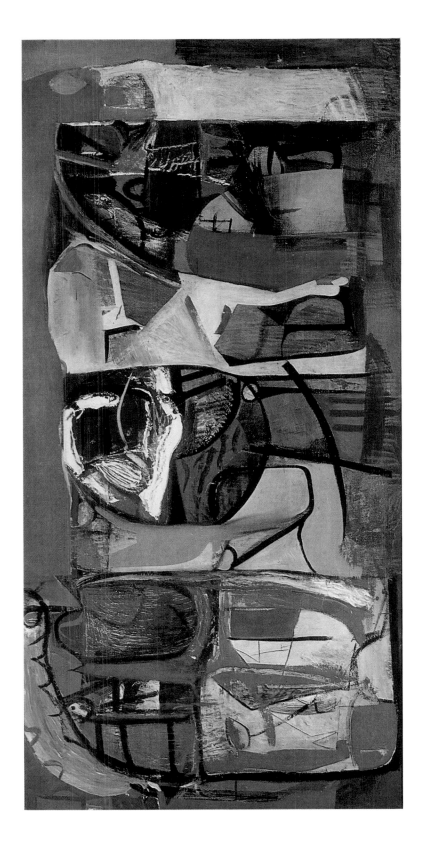

Bojewyan Farms

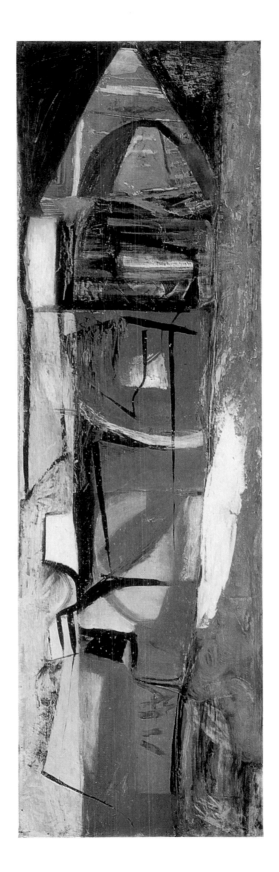

Plate 29 **Green Mile**

stress particular visual relationships he found interesting and to pay greater attention to the needs of the picture. But it is still very much the painting of something that was seen. Looking down over the harbour at Portreath does give the experience of separate but interlocking flat planes staring back. Lanyon was always excited by painting, like Piero della Francesca's, in which energy is gathered and intensified within defined areas which seem to answer back to the eye's enquiry.

In 1949 Lanyon had his first exhibition in London. The largest painting there was **Cape Family** (1949, 72 in. × 48 in.), *Plate 12*. Lanyon explained that it represented a family which lived by the sea at a cape. The father is on the left, the children in the centre and the mother on the right, separated by vertical columns of granite. This curious subject may have arisen from his interest in the old tin mines like Botallack, which stand right on the cliff edge and extend under the sea, and in the people who worked in them. He seems to have wanted to associate the family, and the ideas of generation and continuity, with the point where the sea and the land surface meet. It is a bold archetypal theme for which Lanyon researched into primitive art and medieval illumination and ivories to get ideas for the figures. It is not a complete success. The peaky little faces look rather incongruous among the rocks, and the colour is not strong enough to bind the large surface together. Lanyon did not give up figure painting after this, but he abandoned painting faces for a fuller and richer treatment of the figure as a whole.

Towards the end of the 1940s Lanyon was increasingly adopting Nicholson's technique of scraping paint off the picture surface to create interesting and varied textures. This gradually became a handicap, restricting his natural development as a colourist. The breakthrough to a freer and more expansive use of paint coincided with his achievement of a less private, if no less personal, form of painting. The turning point was **Porthleven** (1951), *Plate 27*, Lanyon's response to a commission from the Arts Council in April 1950 to make a large painting (at least 45 in. × 60 in.) for the Festival of Britain exhibition '60 Paintings for '51'. The commission was a form of public recognition which stimulated him to a quite sudden independence of Gabo and Nicholson. He had benefited enormously from their presence in St Ives, not only in the 1939–40 constructions, but again after the war, especially in 1948–9, when he was afraid, perhaps, for the chaotic consequences of his own romanticism in the generation series.

Porthleven is a fishing village near Helston. 'The village lies at the end of a long steep valley, and you look down at it from the hills on either side. The harbour is constructed in the estuary itself – there is a long outer harbour, a central one controlling the waters, and an inner harbour enclosed by lock gates. The water runs right down through the middle of the picture, which is rather like an aerial view.' The painting was the largest Lanyon had done (48 in. × 96 in.) and the surface was more lively and expressive than anything hitherto, which is perhaps partly an indication of the very short time (four hours) that it took him to make the final picture. The preliminary work involved drawing on the spot and six three-dimensional constructions. In the latter, Lanyon secured his grip on the feel of the place by working out the relationship of different parts in real space before committing himself to the illusion of painter's space. Till then his constructions had been independent experiments not related to specific pictures. Now he rejected that approach: 'I was not content to play variations on a theme of areas and

dynamic tensions. I discovered that when I began to construct a space I was invaded by images of a misty kind which became more insistent as I tried to suppress them in the interests of structure'.[3]

From **Porthleven,** *Plate 27,* onwards Lanyon made constructions to assist the transfer from what he called 'the gathering process' to the process of forming the picture. They were a kind of therapeutic, manual activity, through which meaning was released. 'They are not space constructions but are indications of a constructive process.'[4] With **Porthleven** the constructive process was long drawn out; he never needed to make as many as six constructions for any later picture. At the time, as he said: 'I had not evolved a way of developing an image in my mind and had to explore it in actual space before painting it.' In the painting the stiffness of **Portreath,** *Plate 11,* is replaced by a relaxed articulation of parts; there are certain enclosed sections of the picture – a circle on the left, a square on the right, the ellipse of the inner harbour near the bottom – which contain semi-separate areas of stillness or activity, but each is linked to the pattern of the whole through the vertical emphasis flowing down the picture. **St Just,** *Plate 1,* painted in 1951, the year **Porthleven** was finished, is the same size and shape, and possesses an even more pronounced vertical emphasis. One problem not satisfactorily solved in **Porthleven** was the relationship of drawing in paint to paint areas: some of the drawing at the top, the clocktower and the areas to its left, relates too directly to the pencil sketches to be at ease with the more purely painted areas of the picture. **St Just** is flawless in this respect. It is a grand statement of the artist's experience of the place, and is completely coherent as a painting. The grey left-hand side represents the village of St Just, its hardness and separateness from the adjacent green truly representative of the way granite buildings stand on the landscape and not in it. The grey, physically on top of the picture, allows occasional glimpses of rich dark grass to show through, and is enlivened by small touches of yellow gorse or lichen. The right-hand side of the painting is predominantly green, the yellower greens being laid over the darker, greyer ones. Again a few touches of yellow or ochre brighten the harmony of black-grey-green; in one tiny area blue, red, and white appear together in a startling contrast to the very moderate tempo of the colour changes over the rest of the picture.

St Just was the centre of the mining district of the far west which Lanyon passionately believed had been exploited and its richness removed by owners who felt nothing for the region and its people. The village had known great loss of life in mining accidents caused by negligence and bad maintenance. Lanyon's anger is made explicit in the painting through the form of a crucifix which runs down the centre of the painting like a black mineshaft, with two arms and a tangle of black lines round the head which Lanyon looked upon as a crown of thorns. At other times he spoke of the crown of thorns as barbed wire round the old minehead, but once observed, the likeness to a crucifix became absolutely real for him. A complex pattern of ideas formed in Lanyon's mind round the painting **St Just**: the mineral richness he felt below his feet, the greed of others in exploiting it, the shadow of death over the village. The great black divide that physically splits the painting is an image of death as well as being simply a hole in the ground.

St Just, *Plate 1,* is a good painting because Lanyon is completely at ease in its large and

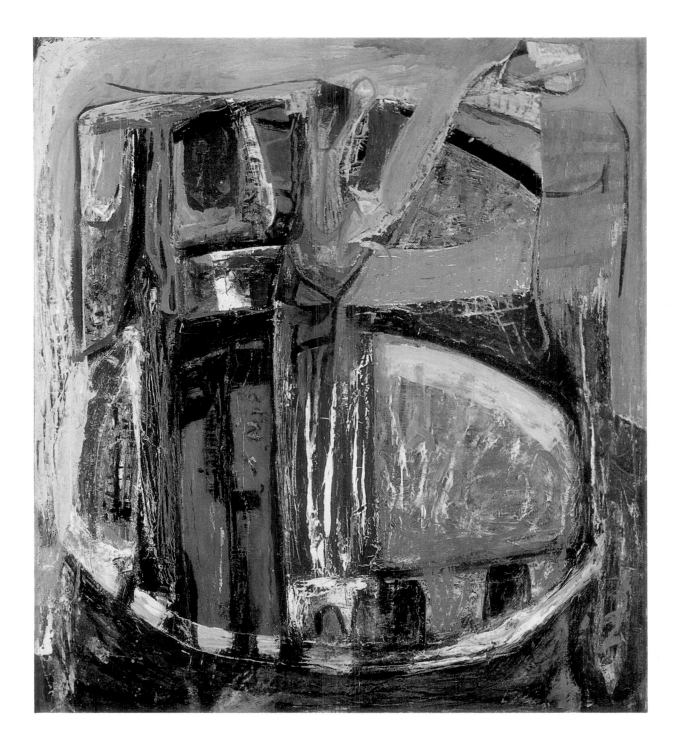

Plate 30

Saracinesco

intricate paint surface. The character of the subject pervades the picture but does not impose itself in detail on the pictorial organisation. He has fully resolved his basic predicament of finding a way of presenting landscape without conventional perspective. His scheme is not quite the multi-viewpoint method of the Cubists, which superimposed visual images within a finite space. His position is less definable. His painting does not describe exact distances or areas, yet it is about very particular places. Essential qualities of an object or place are not just visual; they are of all the senses. His painting from **St Just** is an amalgam of essential qualities, like distance and nearness, hardness and softness, density and transparency, grass and granite, transformed into something new. This newness, the essential separateness that a painting has from whatever inspired it, is important: 'The painting is primary. The painter constructs out of experience making an object which modifies and develops further experience.'[5]

St Just was intended to be the centrepiece of a triptych. The sides (which would not have fitted exactly) were **Corsham Towers** (1951), *Plate 16*, and **Harvest Festival** (1952), *Plate 15*. The most important is the predella panel, **Bojewyan Farms** (1952), *Plate 28*. 'Bojewyan is a small village near St Just, probably one of the most ancient and primitive parts of the district. This is not a mining but a farming picture – a bucolic scene, rather earthy.' On the left there is grass, hayricks and on top, as Alfred Wallis might have painted it, the sea. Lanyon described the centre as an animal: in the middle is a tight structure like the womb section in **The Yellow Runner,** *Plate 26* – which also had a sea-cliff encounter on the left – and the reddish brown at the top recalls the horse in the womb. On the right is the 'chaff which comes from corn and harvesting'. The first section is an encounter, the second a generation, the third a death or conclusion. The form of the development is maintained within the context of the Bojewyan hill farms, and the divisions between the incidents, like the leading between panels of stained glass, are the dry stone walls that divide the fields.

The predella concept, and the development through three separate but related sets of images, is Italian. Lanyon clearly intended both **St Just** and **Bojewyan Farms,** to be regarded at least in part as religious paintings. Both culminate in death, one being Christian and humanitarian, the other connected with farming and the seasons. **St Just,** as a Christian painting, offers hope of life after death, **Bojewyan Farms,** of new life after the winter. In another sense death may have been intended more as an absolute: the tin mines at St Just were deserted, and most of the Bojewyan farms had been condemned and now stand empty.

Several paintings done in 1951–4 are similar in proportion to **St Just,** but smaller. They are mainly green, blue and grey in colouring, with smaller amounts of the warm colours, yellow, ochre and pink. One group includes **Bicyclist in Penwith** (1951), *Plate 19*, **Corsham Summer,** (1952), *Plate 20*, **Botallack** (1952), *Plate 18*, and **Green Mile** (1952), *Plate 29*; these are serene landscape pictures, in contrast to other more turbulent paintings like **Cape Wind** (1954), *Plate 17*, and **Moor Cliff, Kynance** (1954), *Plate 21*; in the latter group strokes of paint are drawn across the surface and are then balanced or contradicted by strokes at right angles. Both groups share a pronounced verticality, which is not just the result of the pictures' shape, but of emphasis on height within them as well. There is a feeling, even in the calmer ones, of the colours being squeezed against each other by the narrowness of the pictures. 'I paint

very thin tall vertical paintings sometimes. This may be because I am fond of climbing cliffs, and I find them very tall and thin. It is just a matter of doing paintings that are not visual painting so much, but are related to some physical experience.' The pictures are physical in another way: their tall thinness relates to the shape of the standing human figure, and thus establishes a very literal analogy between the artist and his landscape.

Cape Wind, *Plate 17*, and **Moor Cliff, Kynance,** *Plate 21*, convey particularly strongly this sense of denoting the human being tortured by the elements. Like Giacometti's skeletal figures, they are totally exposed. Lanyon was an admirer of Giacometti, in whom he sensed his own 'desire to live on an edge' and his feeling of the desperate need to pursue images as far as they would go without losing all recognisable identity. 'Because of this desperation I am led to explore the region of vertigo and of all possible edges where equilibrium is upset and I am made responsible for my own efforts for my own survival. Without this urgency of the cliff-face or of the air which I meet alone, I am impotent.'[6]

In other pictures of the same period, which do not have the vertical emphasis, rich paint is built up within self-contained areas. In these Lanyon temporarily abandons the comprehensive viewpoint to focus more closely on specific objects like the granite stones of **Farm Backs,** (1952), *Plate 2*, and **Boulder Coast** (1952), *Plate 61*: 'I was fascinated by the boulders that I saw in fields on the edge of the coast near Zennor. A close-up detail of them tells you a lot about the landscape – it shows the way the granite has been weathered by centuries of wind. Rocks and boulders are for me stones with human history and meaning.' Compared with **Bojewyan Farms,** *Plate 28*, in which the winding contours of the stone walls enliven the whole surface of a massive painting (48 in. × 96 in.), the considerably smaller **Farm Backs,** and **Boulder Coast,** are dense, heavy paintings like the rocks they describe. Curiously, at the moment Lanyon comes in closest on the object of his study, he also comes nearer to abstraction. The smooth, wind-worn corners of the stones are recognisable as such, their density and their patches of rough lichen are immediately felt. At the same time their shapes are open and frontal like the planes of **White Track,** *Plate 25*, and they constitute a coherent formal statement without argument or narrative.

Lanyon spent the first three months of 1953 in Italy on an Italian government scholarship, living for a short time in Rome, and then moving into the foothills of the Abruzzi mountains to the village of Anticoli Corrado. In the early spring he paid several visits to the hill town of Saracinesco which had been barely accessible during the mid-winter months. 'It is a walled town, with a wall running round as it does in the picture [**Saracinesco** (1954), *Plate 30*]. The stone is limestone which is not as hard as Cornish granite, and a different colour. In fact the most Italian quality in the painting is the colour, for the place itself is rather like Cornwall, which is probably why I went there.' **Saracinesco** retains the black wall and dark green grass of **Bojewyan Farms,** and has sky round the top left-hand corner where there is sea in the earlier picture. But an increase in the range of colours breaks new ground. Till this time Lanyon had been very limited as a colourist even in his grandest pictures like **St Just,** *Plate 1*. After the Italian trip he was to develop into one of the few great British colourists so far this century. In **Saracinesco,** it is not just the way the bright red is placed on top of the green, but the orchestration of

browns, reds and blues in the top half of the picture that indicates the magnitude of the change. The reds in this painting and **Europa** (1954), his most important Italian paintings, are the innovation that strikes one first, but what matters for Lanyon's future is the handling of the whole range of warm colours: later he was able to make more of the browns in his native landscape – the tinstone areas of **Wheal Owles** (1958), *Plate 31*, and the bracken-covered hills seen from the air in **Rosewall** (1960), *Plate 33*, and **Long Moor** (1960), *Plate 34*, – than he had before he visited Italy.

In **Europa,** *Plate 32*, an area of strong red on the right is a direct unequivocal statement of a colour not derived from nature that is without precedent in Lanyon's painting. In a colour sense the picture is a development and modification of this statement of red. Along the base red mingles with darker colours to form an area of extraordinary richness. Above that, in the centre of the picture, the resulting reddish brown lies across the white area intensifying it as it approaches the blue-black on the left. The colour follows directly from what Lanyon saw: 'For me this is a story about primitive life, about living among the animals. The god comes to Europa in the form of a beautiful white bull and from their union the Minotaur is born. This seems to me the most appropriate myth for this district where people sometimes sleep near the animals for warmth in the winter. I was fascinated by this strange animal-human relationship. It is something very basic that could be lost if we become too sophisticated. In the painting the scene is set in the landscape. The forms of a girl and a bull are all mixed up with the heads on the left side. The red colour comes from the primitive habit of hanging out a red blanket after nuptials.'

Lanyon's interest in the Europa myth had been triggered off by the white oxen he saw in the streets of Anticoli, but he had already been interested in animals playing a semi-human role in **The Yellow Runner,** *Plate 26*. A pantheistic undercurrent, in which human and animal activity, and the vitality of nature, merge and co-exist, threads its way through Lanyon's painting. He was interested in myth, particularly as it was manifested in Mediterranean art and culture, and gained through it an understanding of a concept of life in which gods, men and animals are less completely and permanently differentiated than they are in our own thought and beliefs.

A third Italian painting, **Primavera** (1954), *Plate 24*, was a recollection of a trip up to Saracinesco in the early spring before the snow was quite gone. The girls were out in colourful dresses for the Festival of Spring, and the town was bright with dwarf cyclamens and other early flowers. Lanyon's thoughts might well have turned to Botticelli's *Primavera*, but such a figurative representation would not have suited his idiom, and in his own picture he records spring only through the brightness and richness of its colour.

Lanyon was fond of Italy and knew its art galleries well. He had first been introduced to Italian painting by Adrian Stokes, and after being in Italy during the war, he returned there later on three long visits in 1948, 1953 and 1957, while during the same time he spent no more than a weekend in Paris. One of the most important discoveries of his 1953 visit was Giorgione. 'In a poetic way his figures are integrated with landscape', Lanyon said of him, and when he returned to figure painting with **Susan** (1958), *Plate 35*, in he was himself able to merge figure and landscape in a personal and original way. Lanyon's drawings from the female nude are direct and

sometimes erotic. But figure paintings like **Susan,** *Plate 35* and **Beach Girl** (1961), *Plate 36,* though they still derive from visual experience, are more universal in their implication of an analogy between woman and nature. They are human landscapes. Lanyon was no art historian, but he was able to make personal connections with the art of all periods and places. After Italy he became attached to one of the Rembrandts in the National Gallery, *Saskia as Flora,* for the magic with which it married the idea of fruitfulness in woman with the richness of nature.

The Italian trip of 1953 offered Lanyon enormous fresh stimulus, to which **Saracinesco,** *Plate 30,* and **Europa,** *Plate 32,* especially bear witness. But there was not – there never was in his work – a sudden change. The non-Italian paintings of 1954, like **Moor Cliff, Kynance,** *Plate 21,* are more brushy gestural paintings than any of the Italian pictures; they lack the slow deliberation and purposeful colour experiment of **Saracinesco** and **Europa.** The next signs of a new confidence which was to lead to the majestic pictures of the late fifties and early sixties, become evident in the 1956 paintings, particularly **Lulworth,** *Plate 64,* and **Tamarisk,** *Plate 37.*

Lulworth is basically a blue and black painting with touches of red, an aerial view of the Dorset cove combined with a profile of a couple about to have their photographs taken by a cameraman. The figures are drawn in black lines which also refer to the contours of hard flints found embedded in the soft chalk of the area. It is an agitated painting with scraped lines in the black curve of the bay. **Tamarisk** too, painted after seeing the tamarisk hedges near St Michael's Mount, is covered with myriads of tiny striations on the board under the top level of paint, but the picture itself is serene and controlled. The very pale bay at the top stands incisively against the green on the left, while on the right gusts of grey sweep over the calm blue; below, a light earth brown rises through the green only to be denied by heavy strokes of dark grey. The stillness of a calm sea against a green headland, gusty squalls on a clear day, dark shadows over a warm earthy landscape, are handled with certainty. The colour scheme is not vastly daring, but effect is obtained without empty gestures, and drawing and painting are more completely integrated than they are in **Lulworth.**

Tamarisk shows Lanyon moving away from the vigorous rather strident execution of **Moor Cliff, Kynance,** and into a more poised and basically more complex idiom, which crystallised in **Silent Coast** (1957), *Plate 38,* a magical painting whose apparent simplicity masks great subtlety. It is divided into three areas: the largest is the rich, blue bottom section, followed by the whiter blue of the top part, and the right-hand area, which is largely white, with black, ochre and a tiny touch of yellowish green The lower blue section of the sea is deep and rich, executed in multi-directional brushstrokes, with brownish greens showing through towards the bottom like islands encircled and lapped by waves. By contrast, the blue of the sky is painted in broader, horizontal strokes, and again tends towards brownish green at the edge. The third area is a foil to these great passages of blue, one of conflicting activity, of varied texture and surface against the better definition of the blue areas. This picture was one of Lanyon's first declared attempts to paint the weather. 'Silent Coast was a very calm picture, with everything simplified and pushed right to the edges. I painted it very high up, looking down on a broad expanse of coast. Everything was still and slow-moving, as on those days when after stormy weather one gets an extreme silence and restfulness round the coast of West Penwith.' The absence of any drawing in the

Plate 31

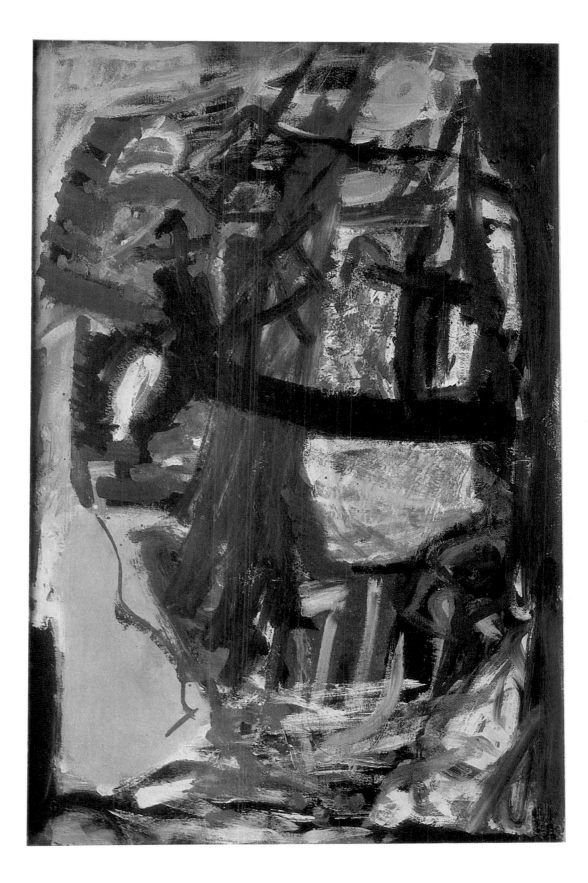

Wheal Owles

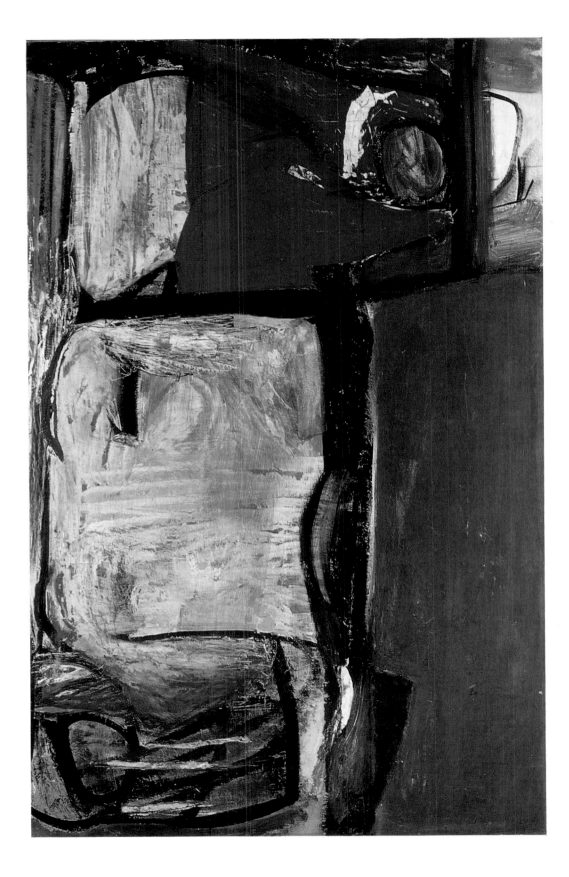

Plate 32

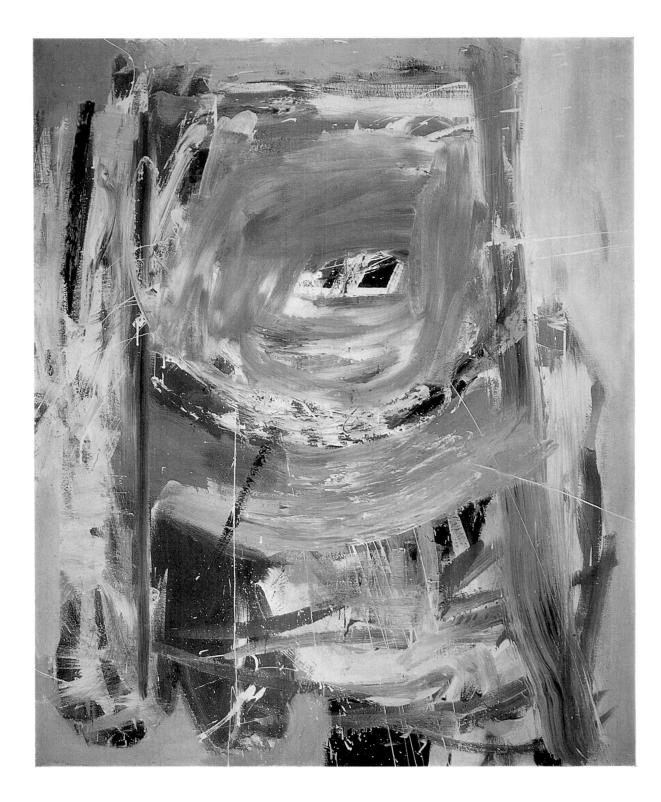

Plate 33 **Rosewall**

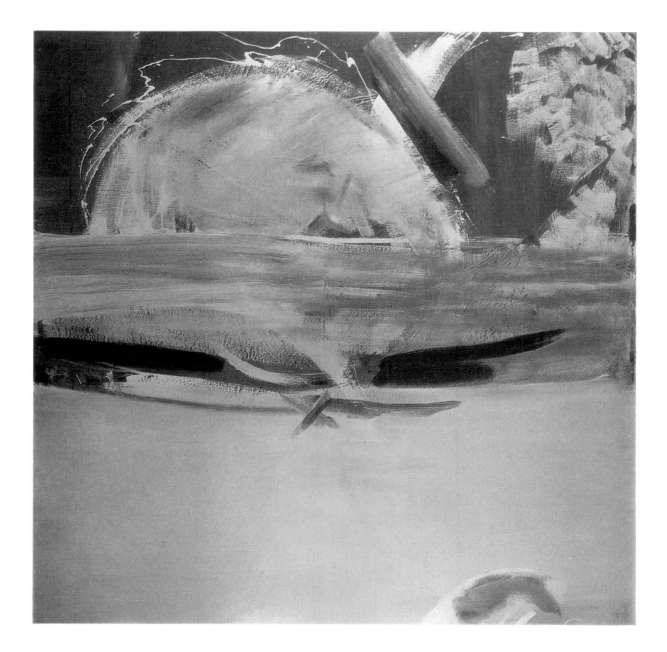

Plate 34 **Long Moor**

paint allows the paint areas, as Lanyon says, to push against the edge of the picture. The whitish blue of the sky and the clear deep blue of the sea on a sunny day swell and press onto the land area to the right.

Silent Coast followed Lanyon's trip to America for the opening of his first exhibition at Catherine Viviano's gallery in New York. He liked America and its painters, among whom his closest friend was Mark Rothko. Obviously Lanyon was influenced by American painting. The change from the tight forms and vigorous but closely organised brushwork of the first half of the fifties to a more open painting with an increased quality of overallness in the second reflects this influence. Modern American painting was becoming better known in London since a large work of Jackson Pollock had been shown in the Institute of Contemporary Arts' 1953 exhibition 'Opposing Forces', a show of French and American painting. In 1956 the first exhibition of 20th-century American pictures was mounted at the Tate.

Lanyon loved the size of American painting, he liked pictures that enveloped the spectator. Though the average size of his work is larger after 1957, all his biggest paintings – **Porthleven,** *Plate 27*, **St Just,** *Plate 1*, and **Bojewyan Farms,** *Plate 28* – were made in 1950–52. The soft spreading paint areas of **Silent Coast,** *Plate 38*, may owe something to Rothko, and some of the paintings of the following years like **Isle of Purbeck,** *Plate 23*, in which complexes of cursive strokes extend over the whole picture surface, are perhaps indebted to Pollock. De Kooning painted themes that touched Lanyon's interests; in 1955 he made his *Woman as Landscape*, and subsequently he painted an increasing number of abstractions with landscape or cityscape titles. But de Kooning's painting was quicker and more impulsive than Lanyon's, and it was only after Lanyon's second visit to New York in 1959, when a further loosening and simplification of form is evident in his painting, that a direct influence of de Kooning is at all likely.

In the years 1956–9 Lanyon did not build quickly on the success of **Silent Coast,** preferring to stay with a more complicated paint surface. It was only when he started gliding in 1959 that he was able to experience the direct physical contact with a non-substantial atmosphere which led him to produce the diaphanous flowing paint areas of the 1959–61 pictures.

The best pictures immediately before Lanyon started gliding include **St Ives Bay** (1957), *Plate 22*, **Dry Wind** (1958), *Plate 62*, **Harvest Mile** (1958), *Plate 66*, **Barley Wind** (1958), *Plate 63*, **Isle of Purbeck** (1958), *Plate 23*, and **Wheal Owles** (1958), *Plate 31*. These paintings have more intricate colour arrangements than most earlier ones, with reds, browns and yellows playing an important role. Surfaces are more broken up, and there are few extended areas of a single colour. **Harvest Mile** is partly exceptional, with the powerful harvest yellow counter-posed by the strong blue of the sea; below the main yellow area, yellow is crossed by blue, and the orchestration established here is resolved in smaller strokes across the rest of the picture.

A similar approach, only with rather less concentrated areas of colour, is worked out in **Isle of Purbeck** and **Wheal Owles.** The first is one of several landscapes painted after a visit to Dorset in 1958. Reddish browns lie partly disguised beneath layers of blues and greys. Their warmth shows through and helps to stabilise the elusive blues that sweep across the surface.

Wheal Owles, *Plate 31*, is perhaps the most exciting painting of 1957–8. A strong red, partially denied by whitish strokes across it, and rich deep blues across the centre and bottom of the picture, establish the basic play of colours. The eye is carried from one to the other through a brown which has elements of both. 'Wheal Owles' means 'mine on the cliff' and here refers to a defunct mineshaft in the garden of Little Park Owles, Lanyon's home overlooking the sea at Carbis Bay outside St Ives. The painting also incorporates ideas taken from another mine, Levant, farther down the coast towards St Just, where the reds and browns are much stronger than they are in his garden. At Levant, he said, 'the thrust and extraction of the industry have left a more definite scar. These derelict mines are a feature of the Cornish coast and are a monument. They are also a wound in the character of the native Cornishman. This is the immense wealth of minerals marked by a dark cross. The minerals were copper and tin. The cliff is tinted with iron oxides which give a brilliant red.'

The paintings of 1957–8 do not have the structural clarity of **Tamarisk,** *Plate 37* and **Silent Coast,** *Plate 38*. They are daring in a different way; their involved brushwork incorporates deeply considered colour inventions, and they represent a significant advance on the Italian pictures in the treatment of the warm colours. **Saracinesco,** *Plate 30*, and **Europa,** *Plate 32*, revealed the possibility of Lanyon developing into a great colourist; the 1957–8 paintings show him beginning to consolidate.

In 1959 Lanyon took up gliding. His conviction that a place speaks for itself, not in an abstract or objective way, but through the experience of the person who involves himself in that place and recounts his experience of it, meant that he had to gain knowledge of his surroundings in the most complete ways possible. Nature was something continuous, without edges and boundaries, and its continuity was not just a visual one. It was a sensuous continuity defined through personal experience. A hilltop, a cliff edge, an undulating road, involve visual climaxes, dissonances, continuity; they also have effects which are less easily definable, but may include exhilaration, surprise, shock or satisfaction, according to each person's response to the sensuous qualities of texture and surface, light and colour, movement and stillness, hardness and softness, solidity and amorphousness, in a particular place. In the paintings there are feelings of light moving towards shadow, of solid moving towards liquid; of the artist, say, walking over the soft springy cliff grass and suddenly encountering the cliff edge, stopping, and exchanging a chiefly physical experience (walking) for a largely cerebral one (the vertiginous effect of looking down a cliff face); or, alternatively, of the artist on a gusty beach damp with sea spray suddenly finding a pocket of sun and still air in the shelter of a rock or dune. The paintings reflect these changes but they are not just about change. They attempt to define the sensuous qualities of things themselves *and* the way they change, by means of the things' actual identities and the way they affect the physical and mental composure of the artist.

Painting which deals both with things and the way they change is very much of the 20th century. Lanyon's art relates also to the 18th: not to 18th-century painting because, though Lanyon admired landscapists like Richard Wilson, he found their single view-point approach to nature basically foreign to what he was attempting; but to the kind of 18th-century aesthetic approach found in Edmund Burke's *A Philosophical Enquiry into the Origin of our Ideas of the*

Sublime and Beautiful (1756), with its thesis that emotion amounts to sensation with a physical basis, and, by extension, to the work of a landscape architect like Capability Brown. Brown, unlike the painters of his day, was dealing with the continuity of nature, the way it completely circumscribes a person; his vistas evolve and merge, his avenues open up and are closed by a folly or a clump of trees; his contours, his gradients, his textures appeal to the senses and satisfy the intellect; they are not simply visual. Lanyon, attempting to describe the same fullness of nature, worked with the painter's restrictions, a flat surface and a small finite area. He had to translate the sensuous qualities of nature into a condensed visual equivalent. He had to find a common idiom to represent the continuity of space in the landscape together with the passing of time as the observer experiences it. His instrument was paint, built in layers on the board or canvas. He marked in his copy of *Colour and Form*, Stokes's comment: 'Thus is time recorded by space: an augmentation upon the surface.'[7]

Gliding was a sensuous experience for Lanyon as much as just a visual one. The controls needed constant attention, and there was limited time for gazing below. What mattered as much as looking was the feel of lifting and falling in air currents, changes of temperature between clear air and cloud, and changes of light caused by cloud shadow or the switch from the highly reflective ground substance of the sea to the almost non-reflective land. Gliding only gradually became the subject of his paintings, but the weather in general quickly played a more significant role. This change can be pinpointed to the year 1959, and is summarised in the painting **Offshore,** *Plate 39.*

This painting has a structural clarity that picks up the implications of **Silent Coast,** *Plate 38.* The basic areas of colour are clearly defined. The setting was Portreath. 'Portreath has a large beach and two promontories, one on the east side and the other on the west. And in the case of this particular picture called **Offshore,** the source of it was at Portreath on what is known as Western Hill, that is on the western end of the beach. Now to approach the Western Hill I went along the beach. The wind was blowing from the north east about half a gale. There was a small gig offshore about two miles out and it could only be seen occasionally. It was bobbing up and down out there apparently fishing. It seemed very dangerous weather to be fishing in. The sea was piling on the shore, the waves one on top of another, almost as if one was seeing it through a telephoto lens, the higher tall waves behind the shorter ones inshore. I walked along the beach and this was on my right-hand side at this time. Then I climbed up onto the Western Hill beside the rocks. The sea then became something down beside my feet. As I moved over the Western Hill the gale struck me straight on. It was very cold, too, though it was in June. I lay down and looked over the edge at the waves coming in, striking on the shore under the rocks there, and breaking off and going away out to sea again. And I came back over the Western Hill, down under the lea in the shelter, and then I sat down in the grass, long grass with a whole lot of remains of sea pinks slightly browning because of a certain amount of sunshine. The sun was about to come out at that time. The grass blew at the sea and the sky became in itself bluer. I moved back into the town leaving the Western Hill behind me.'

Lanyon started the painting with the blue section of the sea, at that stage without the impasto white, following it with the central green section of the hill, and the less definitely structured

area of greyish green on the left. At this point the picture had four blue shores on it, and he felt that 'the masculine-feminine relationship had come out in favour of the masculine'. Subsequently the balance between blue and green was struck by the introduction of the areas of black. 'The rough sea is the male element, and that is both coming in and receding. The Western Hill is the female element.' The black he associated with the town of Portreath, and the black anchor shape towards the middle right of the painting he called the 'return' element, and described it as a 'form of authority'. The picture recalled **Europa,** *Plate 32*, to his mind, and he talked of **Offshore,** *Plate 39*, in terms of the white bull coming up out of the sea to seize the goddess. It may have been when he introduced the vortex of white surf that the idea of what he called a 'celebration of love' formed in his mind. 'I think this is a celebration of love with its grapples and black nets. The gear for the fishing trade is often seen on the island at St Ives which is like this painting: a grass hill sheltered from offshore winds by its southerly slope, and from onshore wind by a town and the mainland. With onshore winds blowing up and eddying over the nets the sea is blown by the wind against its shore movement. Everything tends towards the sea.'

Offshore represents equilibrium arrived at between opposing elements. The black passages are a neutral authority, specifically they are architecture, the town, man-made inanimate non-combatants. The sea, with its rich vortex of surf, tunnels in beneath the black anchor, possesses the harbour, but is held in control by the town's authority, and is half-submerged beneath a screen of black strokes, a kind of formal reply to the white vortex of surf. To the left the sea seeps in through the rich grasses. But the hill too throws her energy against the sea. At the bottom right, close to the town, she is a deep mute green corresponding with the calm rich blue of the sea at the top left. This rises to a more provocative yellow where hill and sea meet. But, essentially for the composition, the green also possesses the very top of the painting. Finally, Lanyon introduced the horizontal strokes of paint in the bottom right-hand corner. They are unrelated to anything he saw, and exist solely for the sake of the painting. Lanyon's personal commitment to the conflict represented in **Offshore,** ended with him painting the back of his head into the picture in the black area at the bottom of the canvas.

The theme of the two opposing forces was developed in the enamel-tile mural that Lanyon designed for the Civil Engineering Department building at Liverpool University in the winter of 1959–60. His subject was **The Conflict of Man with the Tides and Sands,** *Plate 40*, a visualisation in his own terms of research being conducted in the field of loose-boundary hydraulics, which includes movements in rivers, harbours and estuaries, the mechanism of waves, and the behaviour of solids suspended in water. Lanyon conceived the conflict in too broad terms to find room to include the figure of man himself. As in **Offshore** man, in particular the artist himself, participated in the conflicts described in the mural, but the picture itself is a synthesis of these experiences recreated in terms purely of the movements of natural forces. Lanyon spoke of the left-hand section as a 'generator', and modelled it on paddles used to generate waves in the laboratory. It is threatening in mood, as is the whole of the dark arm that reaches across the top to the point where the composition dissolves into a more lyrical white section. Lower down, a large wedge of dark blue represents a breakwater, its unambiguous, architectural structure signifying control, the form of authority exercised by the black 'town'

area in **Offshore.** On a strictly practical level the firm upright in the middle of the composition was needed to stress the height of the mural, which is housed in a foyer only nine feet high. On the right there is sky at the top and, below, sand and a hint of a paler blue sea. The sand is painted in tighter, more agitated strokes than the long grasp of the sea on the left. In painting the arm of the sea reaching over Lanyon may again have been thinking of the rape of Europa. The steep side of the breakwater, the vertical in the middle of the mural, round which are clustered the main colours, dark blue, a paler blue and a golden yellow, is the cornerstone of the composition, and, as the point where land and water meet, the kernel of Lanyon's creative myth.

After **Offshore,** Lanyon was gliding and becoming increasingly interested in the weather and landscape seen from the air, with the result that the deep greens of this painting and the pictures of the **St Just** period now appear very little. But there are other paintings in which the confrontation between two colours is as direct as it is in **Offshore.** In **Gunwalloe,** *Plate 41,* also of 1959, the protagonists are beige and blue – a slightly greyer blue than the predominant one in **Offshore.** In the top right-hand section small areas of beige show through streaks of blue and white. This is a complex, loosely ordered area, but as the eye moves towards the centre of the picture, directed by heavy grey lines, it crosses a tiny patch of green to reach on the left-hand side a more fully resolved statement of the colour confrontation: vigorous vertical strokes of beige have been brushed over blue to form a rough square of colour with blue still showing through. This block is a completely satisfying solution to the dynamic tangle of strokes in the opposite corner across the diagonal.

The simplest colour solution Lanyon arrived at in this period was **Low Tide** (1959), *Plate 68.* Two patches of dark blue were laid on the canvas first in the centre of the picture, with passages of increasingly lighter and whiter blues built around them as the eye withdraws from the sea, down there at the bottom, through the sky to the nearer clouds on the perimeter of the picture. This is a rich painting with mystery and authority in the dark distant blue of the sea. A comparison with the earlier **Silent Coast,** *Plate 38,* which was also built round the encounter of two blues, shows how necessary were the small areas of warm colours in **Silent Coast,** to stabilise and consolidate the picture. **Low Tide,** confined to blue and white alone, is strangely evanescent.

The deep blue of **Low Tide** as a sign of something still and far away is repeated in the following year in **Thermal,** *Plate 67.* 'The experience in **Thermal** does not only refer to glider flight. It belongs to pictures which I have done before . . . which are concerned with birds describing the invisible, their flight across cliff faces and their soaring activity. I have discovered since I began gliding that the activity is more general than I had guessed. The air is a very definite world of activity as complex and demanding as the sea . . . The thermal itself is a current of hot air rising and eventually condensing into cloud. It is invisible and can only be apprehended by an instrument such as a glider . . . The basic source of all soaring flight is the thermal – hot air rising from the ground as a large bubble.

'The picture refers to cloud formation and to a spiral rising activity which is the way a glider rises in an up-current. There is also a reference to storm conditions and down-currents. These

are things that arise in connection with thermals.'[8] Elsewhere he recorded: 'Terrific turbulent action going up on the left-hand side, then slowing down completely into the deep blue below, which is almost completely static like a threatening thunder cloud.'

In 1959 Lanyon made a second visit to New York, and in the same year the Tate held a second exhibition of American painting, this time entirely of post-war work. The new openness of Lanyon's painting after 1959 and his broad sweeps of paint may relate to the technique of de Kooning, as may the dribbles and splashes that appear on the surface of certain pictures. From 1957 to 1960 de Kooning went through a phase of exceptionally broad brushing and open spaces of colour in pictures which often have landscape titles. But essentially Lanyon's painting remained quite different from de Kooning's: less impulsive, slower in tempo, though no less energetic, and rarely conveying the sense often experienced in de Kooning's painting of decisions taken suddenly. One has only to look at the way the paint is blended, colours with white, in the sweeping motions of pictures like **Long Moor** (1960), *Plate 34*, or **Drift** (1961), *Plate 42*, to see the control, deliberation and basic absence of accident in Lanyon's art. These pictures show the mastery of Lanyon as a colourist, and the slow beginning of his independence of observed nature. They still transmit a direct sense of place, but nowhere do specific images interfere with the internal sense of the picture. The best paintings of 1960–62 are perhaps the finest Lanyon made, and are certainly among the great British paintings of the 20th century.

Of **Long Moor** Lanyon noted: 'A landfall. Approach to moor country from the air over the coast. Evening.' At the bottom the bluest corner of the sea touches a segment of brown to establish the basic colour confrontation of the picture. The greenish-blue sea gets paler and whiter towards the shore where it encounters a great dark horizontal divide. Above this is a long band of colour – greenish-browns, blues and browns – like a semi-transparent web drawn right across the picture. Above, a semicircle shaped like the setting sun, varying in colour towards brown and towards grey, rests against a rich brown background. A comparison with a painting of the mid-fifties like **Moor Cliff, Kynance,** *Plate 21*, shows how the marks of the brush are divested in the later painting of their earlier obtrusiveness without losing their energy. Lanyon was insistent that good painting consisted of marks that did not exist as marks but as signals of received experience: 'Considerable training is required to precipitate marks which relate to information. The artist must proceed beyond the inspired guess to certainty. The surest way to inhibit development of a painting is to remain at the guess. Here the mark itself becomes important (it is in fact the small change of aesthetics) and not that which is signified by the mark.'[9]

Rosewall is the hill that overlooks St Ives from the west. In his painting of 1960 Lanyon looks down on it from the air. He repeats the technique of **Low Tide,** *Plate 68*, and again the eye sinks through layers of colouring with a heavy mixture of white till it reaches the pure colour, here the dark brown of the hilltop. The circular, pressing movement in the top half of **Rosewall,** *Plate 33*, with the subsidiary area of yellows and browns beneath it, develops the vortex theme of **Offshore,** *Plate 39*. Lanyon was very conscious in his later paintings of areas of high activity surrounding a still centre. It was something he shared with Turner, whom he found a difficult painter and came to enjoy only late in life. The comparison between the two extends not only

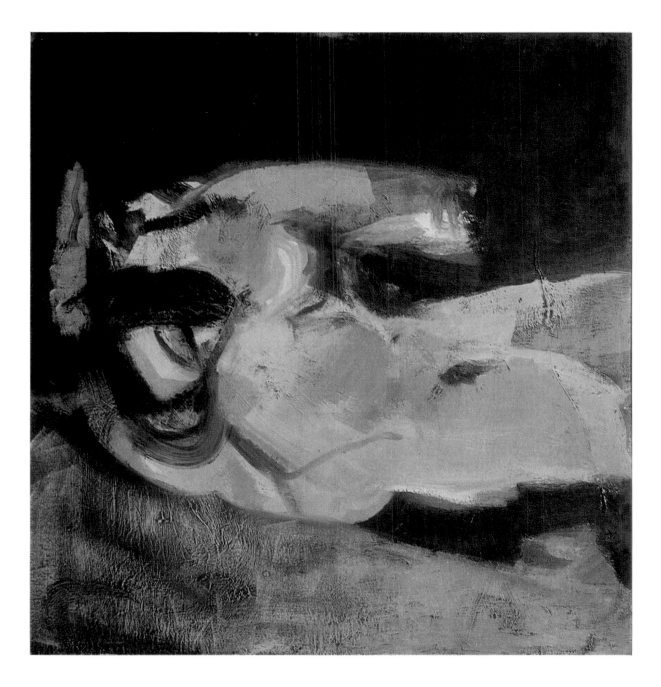

Plate 35

Susan

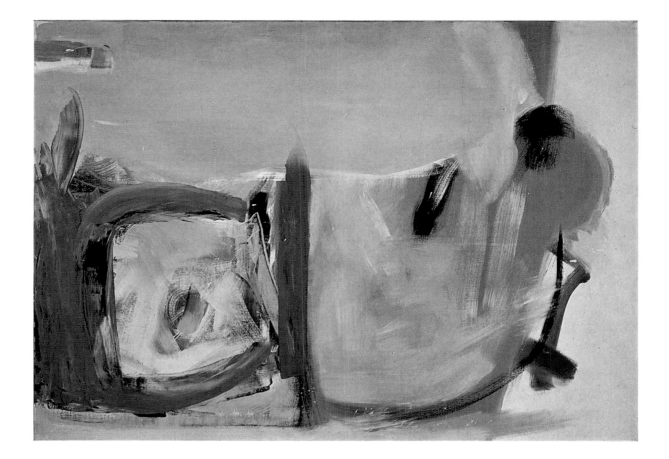

Plate 36

Beach Girl

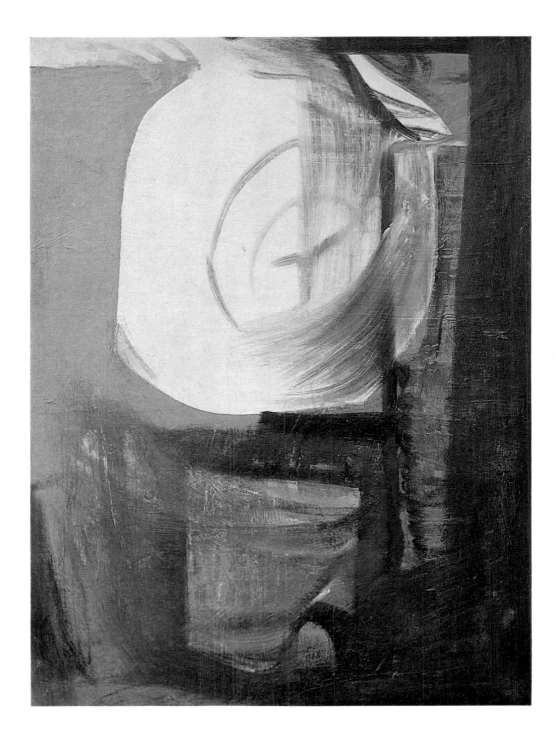

Plate 37 **Tamarisk**

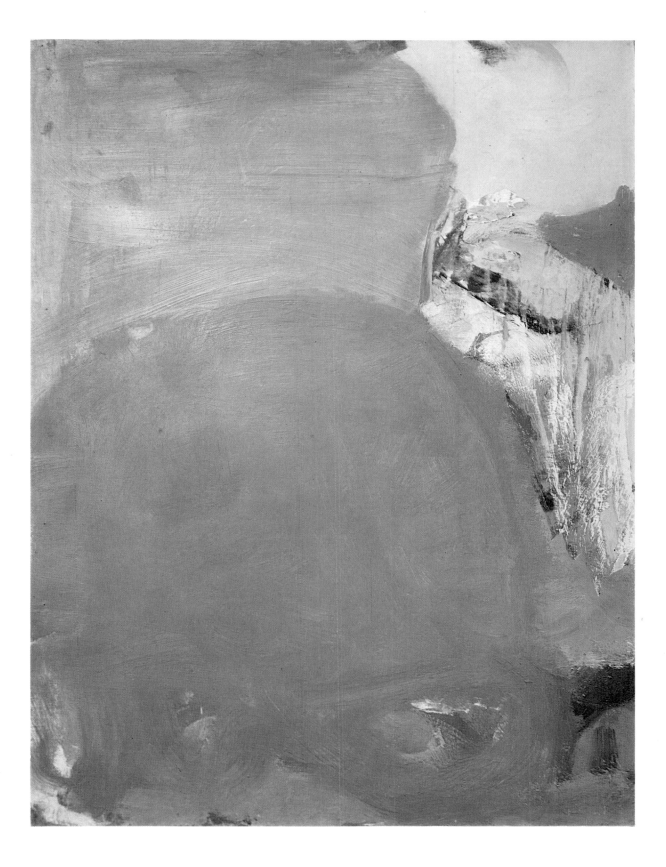

Plate 38

Silent Coast

Plate 39

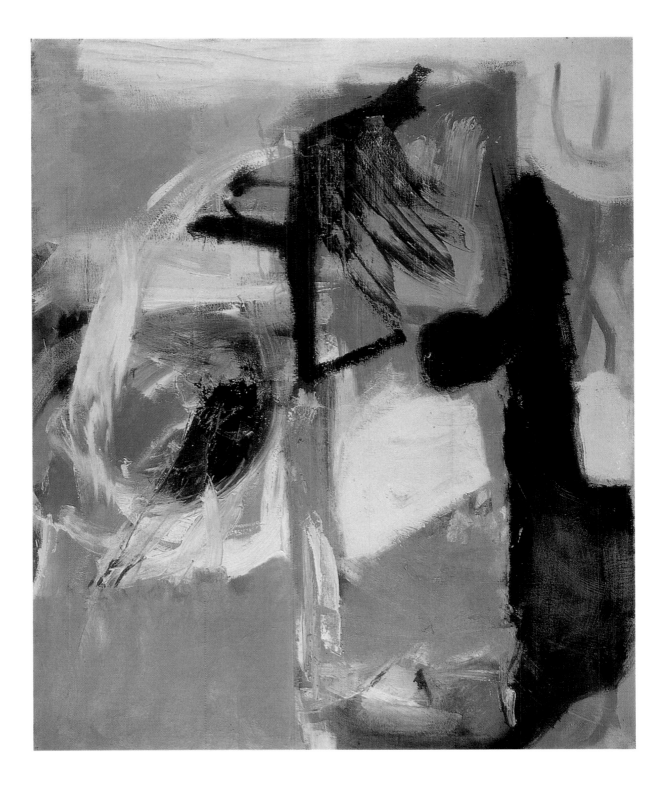

Offshore

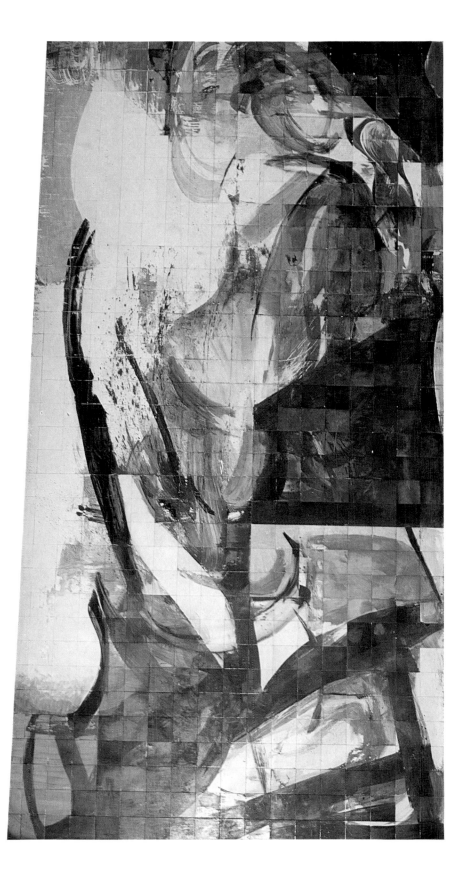

Plate 40

Main Section
Liverpool Mural

to their pleasure in rotatory movements round still points, but more generally to their common dependence on total sensation rather than just observation, and their success in pushing landscape painting as near to the edge of abstraction as was possible without losing some direct contact with visual reality.

The brown centre of the vortex in **Rosewall,** like the blue area in the middle of **Low Tide,** is a distant point towards which the spectator's eye is drawn down. It is also like an eye looking back at him. Lanyon spoke of the way the landscape answered him back the moment he succeeded in capturing its character in his pictures. In paintings like **Long Moor,** *Plate 34,* and **Rosewall,** the use of colour is tonal rather than contrasted. This technique extends into 1961 with **Drift,** *Plate 42,* in which a broad stroke of yellow near the top and a smaller one of blue represent the basic colour confrontation, combined lower down into thick creamy tracks of pinkish-brown and bluish-grey.

The variations of tempo when gliding, the slow rise, the sudden dive, the hovering motion, are reflected in the directional marks within gliding pictures like **Drift.** In others the introduction of red to signify the glider's path initiates a new system of colouring. Describing **Soaring Flight** (1960), *Plate 43,* Lanyon said: 'The red rises up on the left side to set the whole in motion: one almost stays in the inverted V, but then sweeps down to the bottom right-hand corner and back through the brown squiggle up to the red again. It's the way you see a seagull in flight: soaring, hovering, and turning away down wind very fast. The movement goes at different speeds, so does the eye as it moves across and into the picture. The horizontal line of the ground forms the static element against which the dynamic forces can play.' The idea of a track through the painting is clearer still in **Solo Flight** (1960), *Plate 44,* in which a path of bright crimson winds across the picture surface. Strong reds had not been common in Lanyon's painting till then, and when they had appeared, as in **Europa,** *Plate 32,* and, much earlier, in the darker form of the fox in **The Yellow Runner,** *Plate 26,* had been associated with excitement and risk. **Solo Flight** was painted after Lanyon's first solo in a glider, a red one, and is intended to convey the same sense of excitement.

The use of red as a danger signal is carried over from the flight paintings to others like **Lost Mine** (1959), *Plate 45,* a memory of Levant Mine, a coastal shaft, the scene of a famous accident, which was subsequently inundated by the sea. There is a clear image at the bottom of the painting of the sea rising up into the mineshaft, and just above it a stroke of red. A related usage of red occurs in **Orpheus** (1961), *Plate 46,* in which the colour occupies the picture on either side of the horizontal black line which separates the world from the underworld, and of the vertical line which charts Orpheus's route in his search for Eurydice. Here the red could be thought of as a symbol of Orpheus's daring in seeking his wife from the dead, as well as of the painter's own pursuit of the unknown in his art.

Pictorially this use of red began to draw Lanyon away from the style of paintings like **Long Moor,** *Plate 34,* and **Rosewall,** *Plate 33,* with their close-toned, carefully graded colour, and to initiate more direct colour contrasts. A turning point was the third version of **Saracinesco** (1962), *Plate 47,* in which Lanyon groups colours with a tenuous relationship to nature within a formal

fabric which is only very loosely structured. The first two versions of this picture were both the direct results of visits to the town of Saracinesco. This third one was just a memory of the springtime festivities there with their gaiety and brightness.

The positive colour contrasts established here continue in **Two Place** (1962), *Plate 48*, and **Two Close** (1962), *Plate 49*; in the latter a large area of red faces a broad yellow section across only a narrow light passage. It is a bold colour confrontation, and the flamboyance of the picture is augmented by the bluish-green and brown patches over the red and the thin drips and squiggles of brown over the yellow. A more common arrangement in the 1962 pictures, and one that works well, is the establishment of a chief colour – bright orange in two of the best paintings of the year, **High Moor,** *Plate 50*, and **Loe Bar,** *Plate 51* – and the playing of varia-tions on it in subsidiary areas.

These are both weather pictures. **Loe Bar** is a re-creation of the sandbar between Porthleven and Gunwalloe which stops the river Loe from Helston reaching the sea, and forms it into a lake. The single feature of the horseshoe-shaped form, a piece of rusted wreckage standing just to the right of the main area of the sea, rules the picture. The sandy-brown at the top filters through under the white in the horseshoe, and out under its left wing; it shows through under the sea, and even surfaces in a brief horizontal slit like a narrow island. But it does not touch the richest area of blue, which stands clear, divided only by a flash of white from its most formidable antagonist, the orange wreck. **Loe Bar** is decisively different from the earlier aerial views because the orange stands physically on top of the painting. Apart from a few exceptions, like the red in **Solo Flight,** *Plate 44*, the strongest colours were previously applied first, and the whiter ones built round them, partially hiding them and cloaking them with a certain elusive mystery.

In **High Moor,** *Plate 50*, the L-shaped orange wedge, probably referring to lichenous boulders or rocks streaked with iron ore, faces a less-defined area in which white trails track across the surface and double back, allowing glimpses of jewel-like colour areas below, reds and golden-browns, greenish-blues and yellows, to show through. In this picture and **Cloud Base,** *Plate 65*, another weather painting of 1962, Lanyon pushed richness and variety of colouring, in combination with minimum of formal structuring, as far as possible. In any case he was becom-ing increasingly interested in the handling of broader single areas of colour, and the starting point for the important 1963 pictures like **Farm,** *Plate 53*, was more the dominant orange of **Loe Bar** than the more diffused colouring of **High Moor**.

In **Farm,** one of the most individual of the late paintings, a rectangle of red stands free against white on three sides, and a brown triangle below borders white on two sides; in each case surrounding strokes of a contrasting colour, blue, serve to highlight the separateness of the red and brown. In the centre, brown and white are combined, and the strength of the brown is indicated by its survival through a heavy overlay of white. This is still a landscape-inspired painting, but colour is used differently, with greater independence given to individual areas. To this extent the continuity of nature's colouring is challenged.

Plate 41

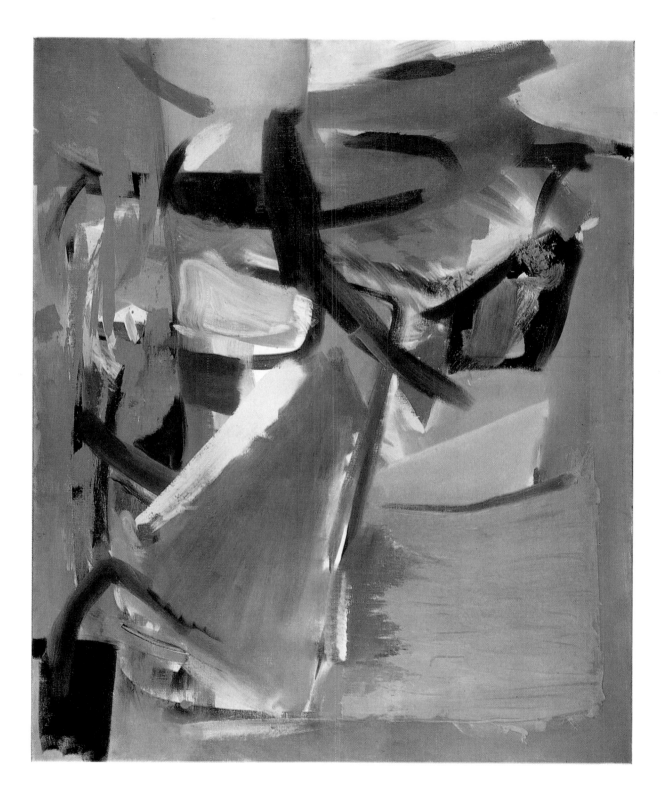

Gunwalloe

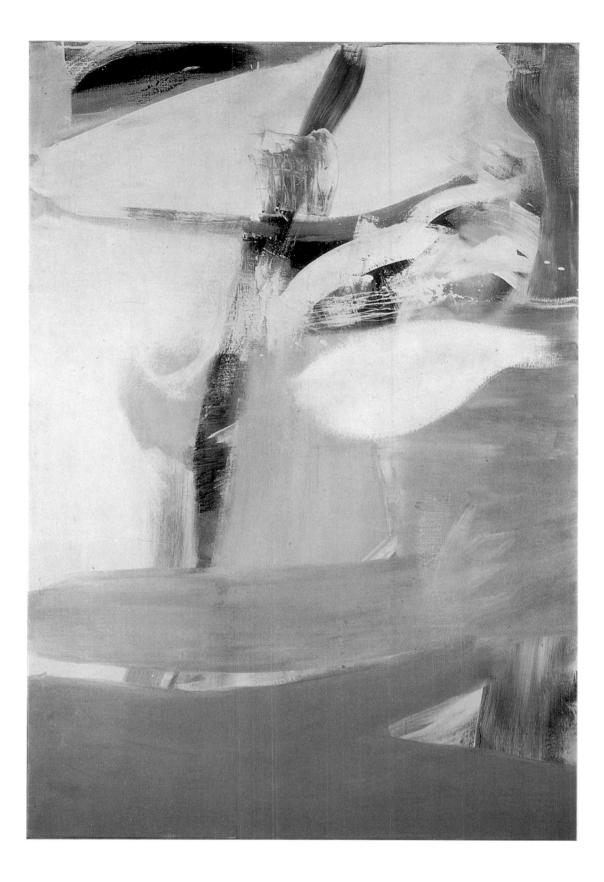

Plate 42 **Drift**

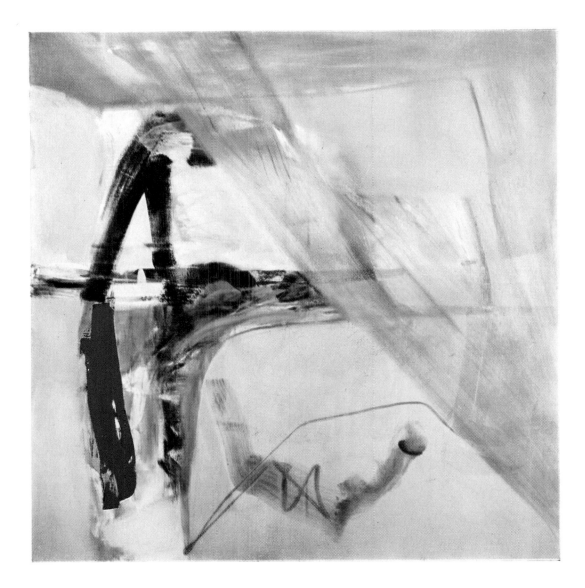

Plate 43

Soaring Flight

Plate 44

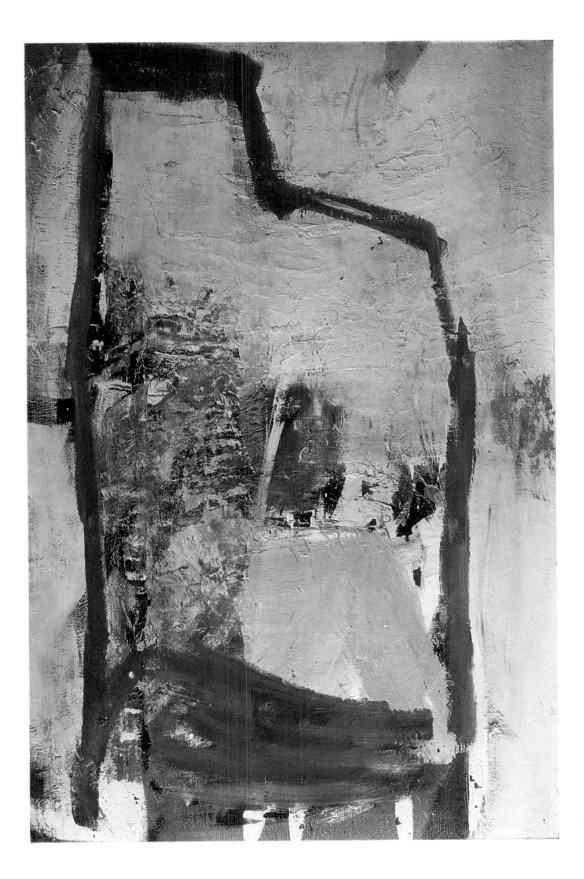

Solo Flight

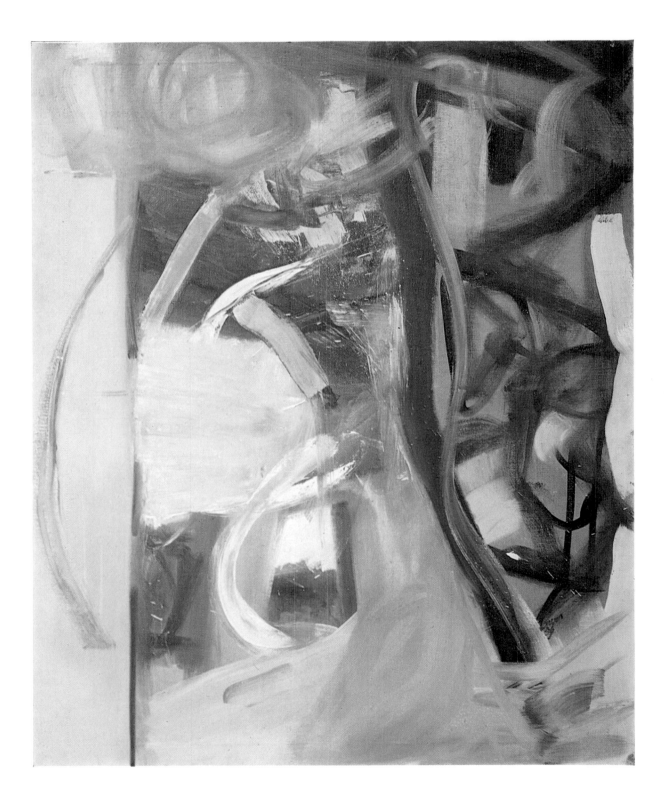

Plate 45

Lost Mine

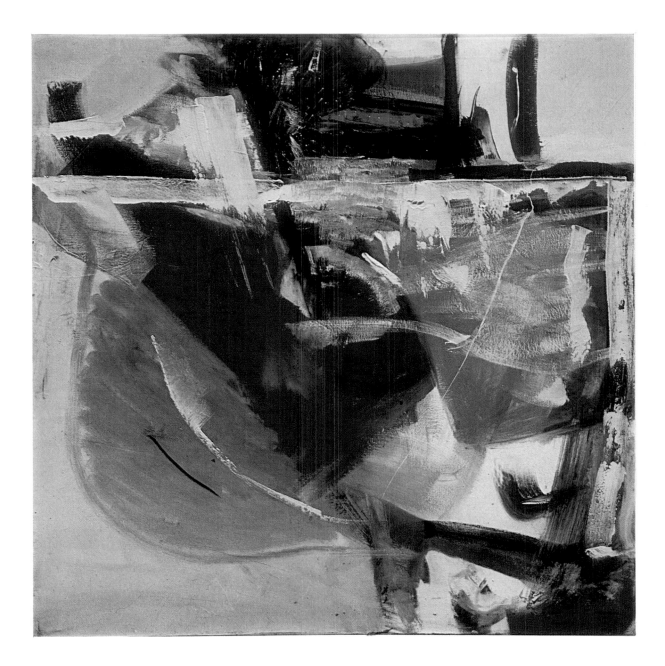

Plate 46

Orpheus

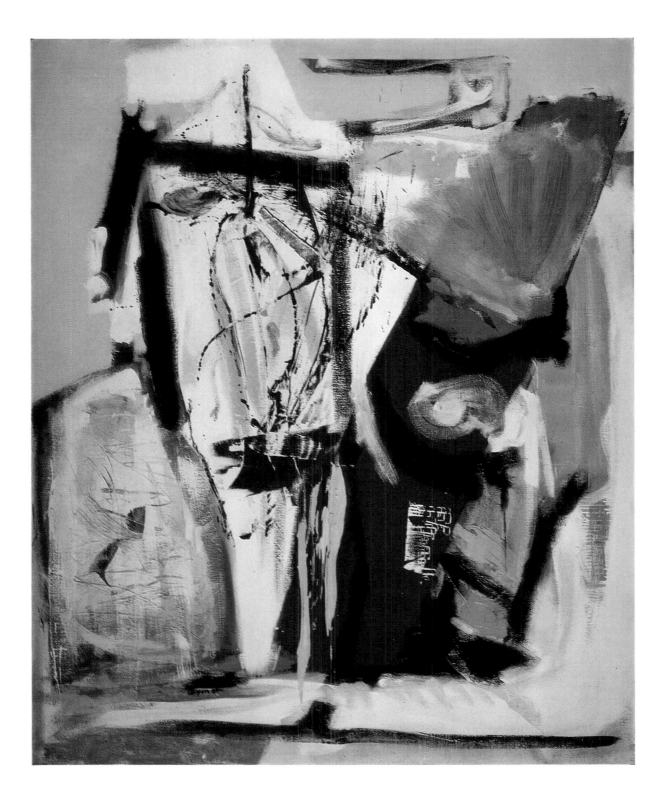

Plate 47

Saracinesco 1961

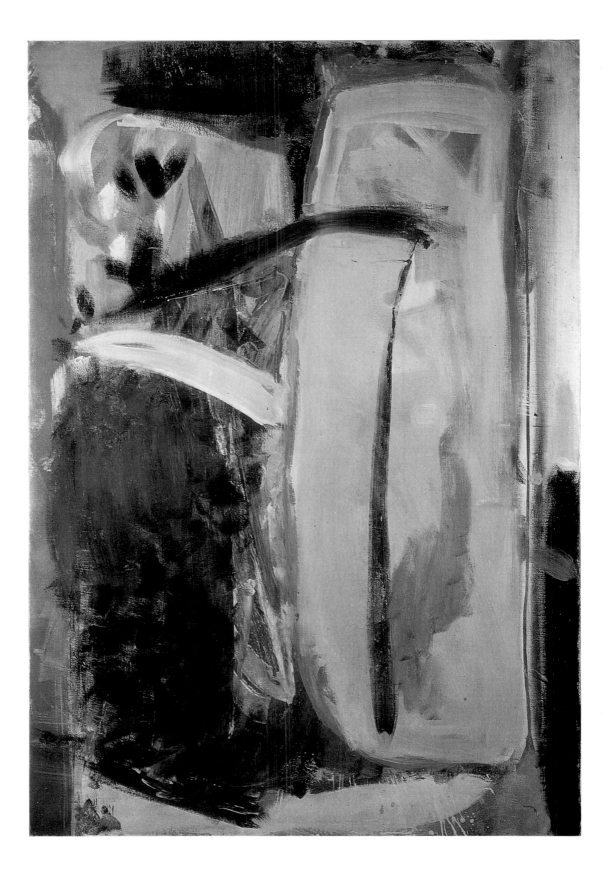

Plate 48 **Two Place**

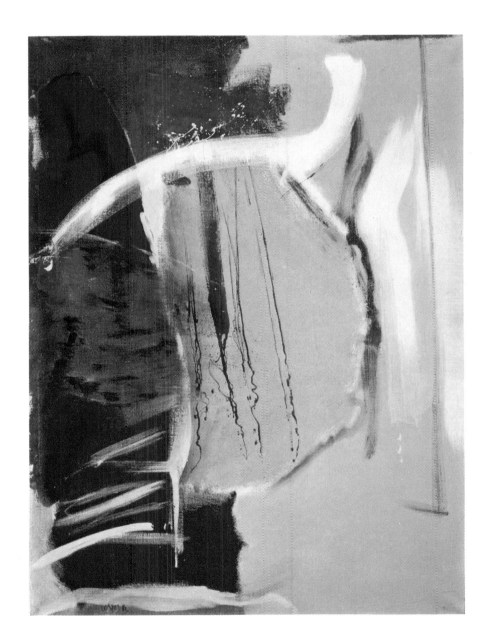

Plate 49 **Two Close**

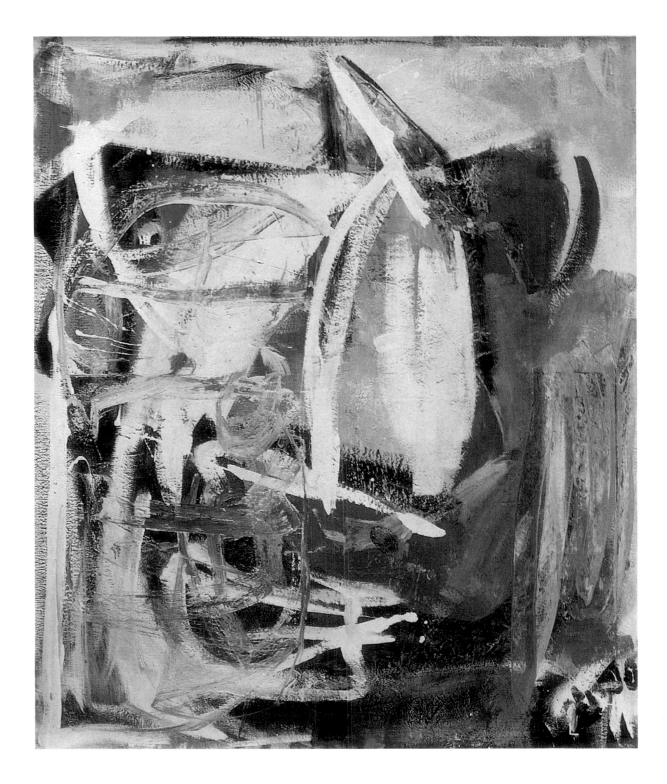

Plate 50 **High Moor**

In the spring of 1963 Lanyon was a visiting painter at the San Antonio Art Institute, Texas, where he collected information for a number of paintings. In one, **Eagle Pass** (1963), *Plate 54*, named after the route which connects San Antonio with Mexico, he formed an image rather like a car seen from the front going along a road. The colours are the warm sunbaked reds and yellows of the country, with cool greens, blues and purples for their shadows. Towards the top a sandy-yellow area inside a red framework presents an entirely new treatment of paint: not only is the shape based on two right angles, which have not appeared before in Lanyon's painting, but the right angles are stressed because the yellow area which they help to form is bordered and accentuated by red edging.

Perhaps Lanyon's finest achievement in 1963 was the mural painting for the Faculty of Arts building at Birmingham University, *Plate 52*. The mural stands in a foyer which is in effect like a broad passageway linking two wings of a building. Opposite sides of the passageway are walled with glass down to the ground, allowing the open grassiness outside a sense of penetration into the foyer. The mural occupies all of a third wall, apart from the swing doors leading to one wing of the building. It has no title, and its subject is the mingling of landscape and architectural forms, grass, trees and elusive shadows, together with more solid brown and reddish architectural forms. The larger colour areas mainly fall towards the edge of the painting, while a kind of central bowl picks up smaller quantities of each. A circular, vortical movement round the periphery is particularly emphatic in the area of the rolling wave-forms at the top. This feeling of movement gives the central bowl something of the character of a wheel, and there are traces of diagonal spokes. Right at the centre is a yellow 'eye' the still point in the middle of the painting. The mural contains a complex of small movements which echoes the activity of the concourse. It is a painting which responds well to the occasional glance as well as prolonged study.

Lanyon was travelling much more than he had done. By 1963 he had visited America four times, and early in 1964 he went to Czechoslovakia to lecture for the British Council on recent British art and on the history of landscape painting since Giorgione. These fresh experiences naturally affected someone who was particularly sensitive to the feel of places. Nothing could detach Lanyon from the landscape as the chief source of inspiration, but his painting from 1963 is not specifically Cornish in form or colouring. He turned to broader areas of colour, wider and flatter curves, and longer strokes of a single colour. In common with many artists in England and America, Lanyon was turning away from the kind of existential painting in which each mark on the surface was a decision to be followed by another decision till, by an accumulation of marks, the image of a personal reaction to, and relationship with, the landscape emerged. The last pictures are more cerebral. More of the detailed decisions have been made before the painting was embarked upon, and the powerful underworking which gives the sense in the earlier paintings of a final image thrown up from underneath, from the body of the paint itself, is gone.

Lanyon's turn from the vigorous painterly style of the years up to 1962 left him uncertain of the way forward. In an attempt to rid himself of the looseness of some of the 1962 paintings he cast around for new pictorial ideas. **North East** (1963), *Plate 55*, shows a reversion to the clear

stringency of Gabo. The central three-armed brown feature derived from the sextant in Lanyon's glider, but its relationship with certain sculptural forms of Gabo, who was originally trained as a mathematician and engineer and was influenced in his own work by the forms of such instruments, is unmistakable. The more faintly drawn blue circles could refer to the curved wires of Gabo's constructions. The way the thickest leg of the brown object is carried onto the edge of the blue in a thin brown line which then turns into a deeper, broader purple one is a neat piece of pragmatic pictorial engineering. Lanyon's uncertainty lasted only through 1963. The last paintings, done in the spring and summer of 1964, are as magnificent in their own ways as the best of 1960–61.

In May 1964 Lanyon visited Clevedon, the north Somerset resort, with a group of students from the West of England College of Art at Bristol, where he had been a visiting lecturer since 1960. He took a large quantity of colour photographs, mainly of the Regency iron pier and the nearby boatpool with its stone enclosing wall and chains of brightly painted boats. The architecture of the pier is most clearly seen in **Clevedon Night** (1964), *Plate 56*, its black legs outlined against the night sea in the centre of the picture. This is a cool, flowing painting in pale and dark blues, pink, a touch of purple, black. It has a pronounced horizontal emphasis, stressed by the two pieces of polystyrene attached below the pier to represent boats. **Clevedon Lake** (1964), *Plate 57*, also has a horizontal accent across the centre, and in the lower half an intricacy which is equivalent in a sense to the pier architecture in the painting **Clevedon Night**. There is a feeling in this section of colour being used, as it was in **Eagle Pass** (1964), *Plate 54*, to outline shapes rather than form them. A certain tentativeness and ambiguity in the construction of the shapes in this lower section hints at a possible connection with the Pop art movement.

The grandest of the Clevedon paintings is **Clevedon Bandstand** (1964), *Plate 58*. The form of the bandstand is evoked by the curl at the top right and the pink area which could be a caryatid. The single broad, more or less circular, stroke of dry white paint drawn over the central area of black represents a dynamic force, akin to the vortical forms of **Offshore**, *Plate 39*, and **Rosewall,** *Plate 33*, but more lyrical. It was a gust of off-sea wind throwing itself at the bandstand. At another level of Lanyon's mind it was the energy and daring of Orpheus, encountering the tall verticals, the gates of Hell, in his search for the pink form of Eurydice. He is elegantly poised in the centre of the picture without subsidiary forms pressing in. The chief colour contrasts, between deep blue and red and between brown and green, are off-centre, and in each case stated through long straight lines. The bandstand is both an independent floating form, and at the same time linked to the peripheral elements by its touches of green and the blue arc to its right. Features like the long straight lines in the painting, and the handling of the paint in the white bandstand image, point to the influence of Francis Bacon, a friend whose work Lanyon admired. In a conscious search into new ways of presenting images, Lanyon was looking again at the work of painters who had not affected him previously. In other ways **Clevedon Bandstand** is a synthesis of Lanyon motifs: apart from the central circle, and its relation to earlier vortexes, the streak of red passing through the blue recalls the gliding and weather pictures, the tall green and black verticals pressed against by brown and blue curves refer back to the vertical landscapes of the early fifties.

Plate 51

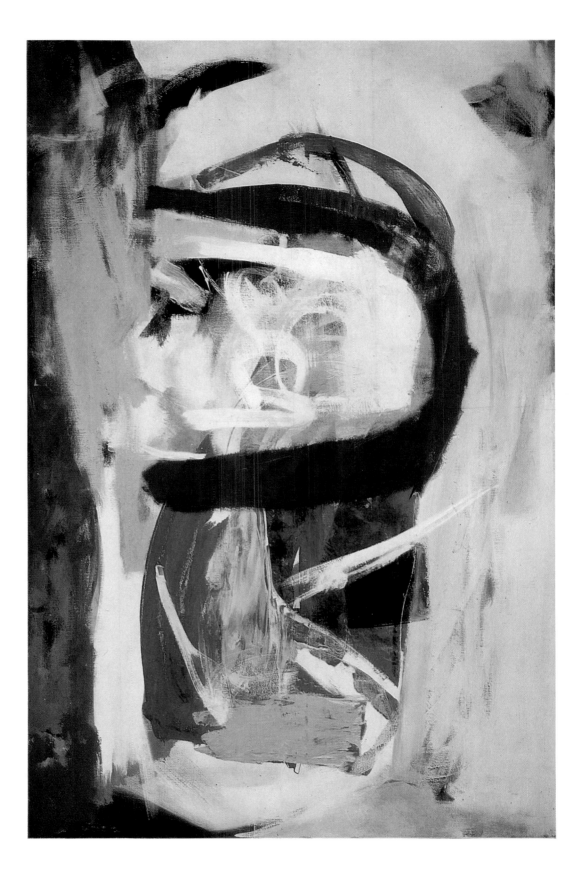

Loe Bar

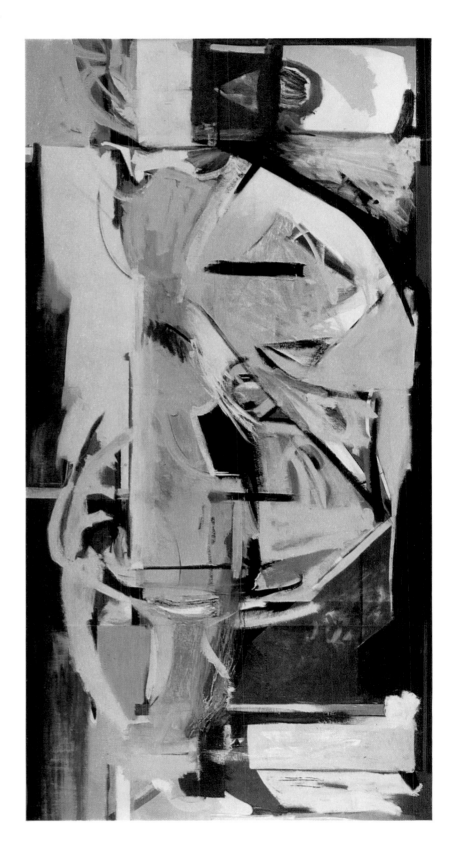

Plate 52

Main Section
Birmingham Mural

Like **Clevedon Night,** *Plate 56*, several of the other late pictures are collages, among them two gliding pictures, **Glide Path,** *Plate 59*, and **Fistral,** *Plate 60*. In **Glide Path** the track of the plane from the land out to sea is fixed by two plastic bars ascending the canvas and converging slightly towards the top. **Fistral,** named after a bay near Newquay, shows a broad open bay marked by a red horseshoe related in shape to the orange form in **Loe Bar,** *Plate 51*, only shallower and this time made of a piece of painted polystyrene laid on the canvas. Two smaller, dark horseshoes rest on a horizontal red band which is like a glide track coming in across a calm sea. At the bottom an assortment of pieces of shaped polystyrene are stuck to the canvas as one might expect to find the discoveries of a beachcomber (which Lanyon was) arranged on a shelf or table. The sensuous reality revealed in the early gliding pictures was no longer satisfying on its own. In **Fistral** Lanyon attains both the sense of being high up and looking down over the sea along a wide sweep of coast, as well as the more tangible reality of the man on the ground who can pick up bits of junk and handle them. There is a parallel between his position in 1964 and that of Picasso and Braque in 1912, when they turned from analytical Cubist painting in which the images had become increasingly fragmented and intangible to the use of collage materials like cloth and newspaper whose actuality was obvious and beyond argument. **Glide Path** and **Fistral** and the other big collage paintings of 1964 have a palpable, tactile presence which is both new in Lanyon's painting, and at the same time looks back beyond the weather and early gliding pictures to the period of **St Just,** *Plate 1*. Within the conventions of oil painting, the landscapes of 1951–4 have a comparable tangibility, such is the faithfulness with which their colours and textures and forms re-create the shape and the character of the landscape.

Peter Lanyon died on August 31, 1964, after a gliding accident. He was 46. His painting since the mid-fifties had shown a variety of invention with few parallels in recent English painting, and his last work suggests that his creative power was intensifying at the time of his death. He had realised his natural talent slowly and with difficulty in the forties, and in the fifties had become one of a very small number of outward-looking and unchauvinistic English painters who attempted to find new ways forward for English art within the context of the modern movement. Lanyon was then fighting for recognition in an atmosphere of general distaste for advanced art with abstract leanings. It is particularly tragic that he should have died at a time when a wider public was coming to acknowledge the significance and value of this kind of painting, to the growth of which Lanyon's contribution must increasingly be recognised.

NOTES TO THE TEXT

Quotations without references are from tape-recorded conversations.

[1]*Painter and Sculptor*, autumn 1962.
[2]*Colour and Form*, by Adrian Stokes. Faber and Faber, 1937, p. 21.
[3]*Painter and Sculptor*, autumn 1962.
[4]*Ibid.*
[5]*Ibid.*
[6]*Ibid.*
[7]*Colour and Form, op. cit.*, p.80.
[8]Letter of November 28, 1960, quoted in the Tate Gallery catalogue entry for *Thermal*.
[9]*Painter and Sculptor*, autumn 1962.

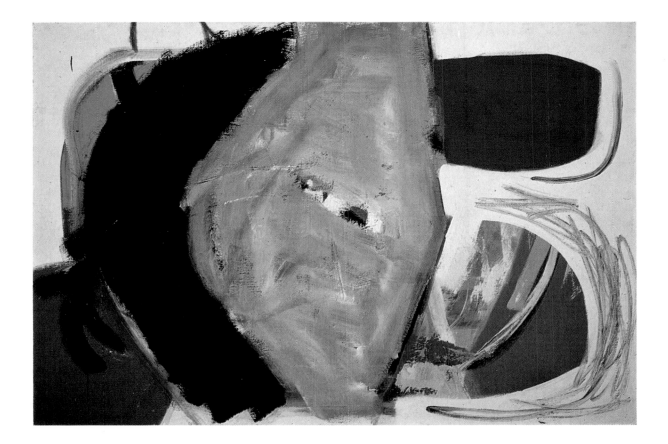

Plate 53 **Farm**

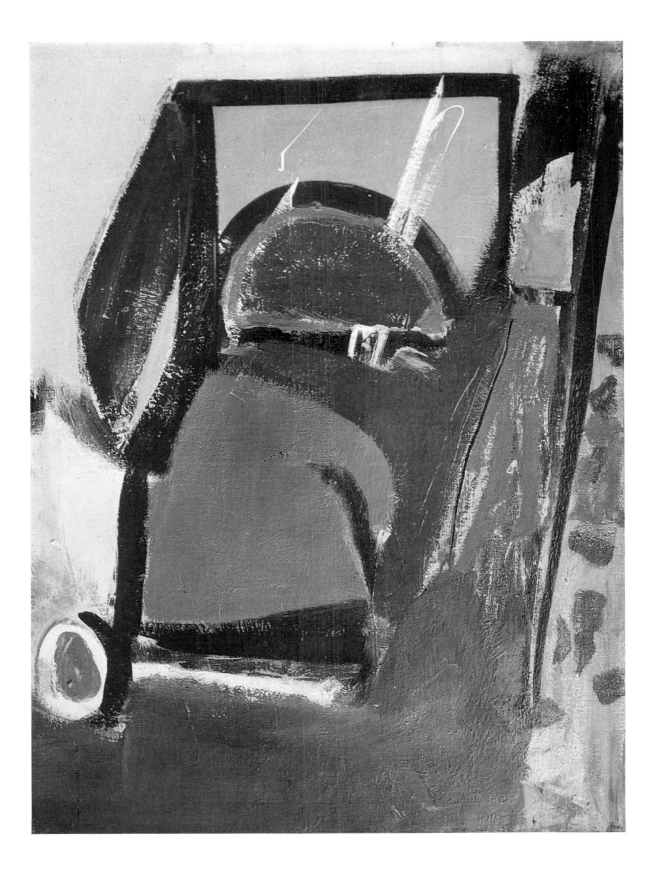

Plate 54

Eagle Pass

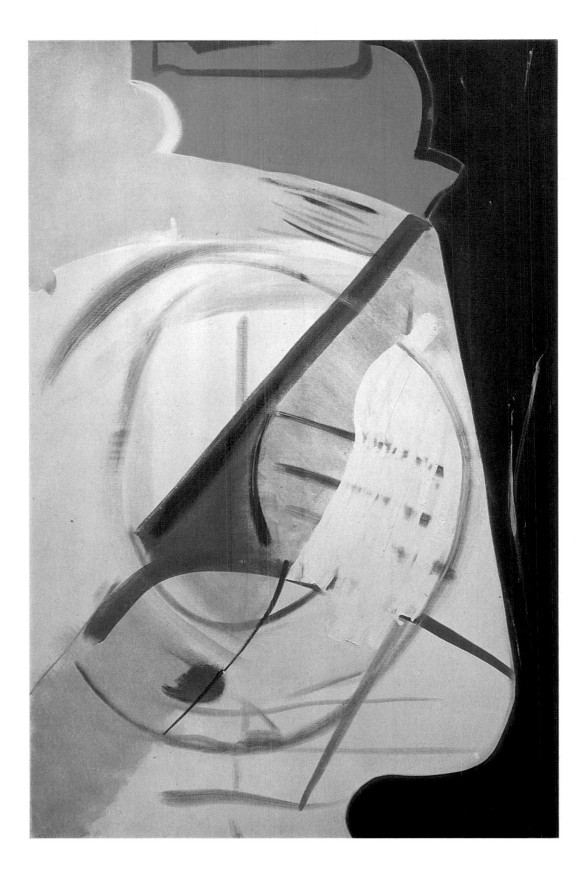

Plate 55

North East

Plate 56

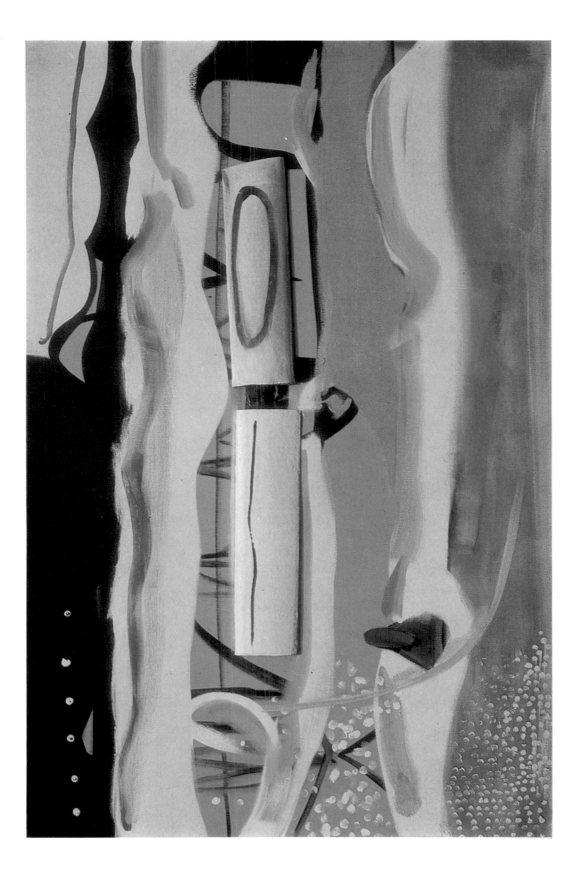

Clevedon Night

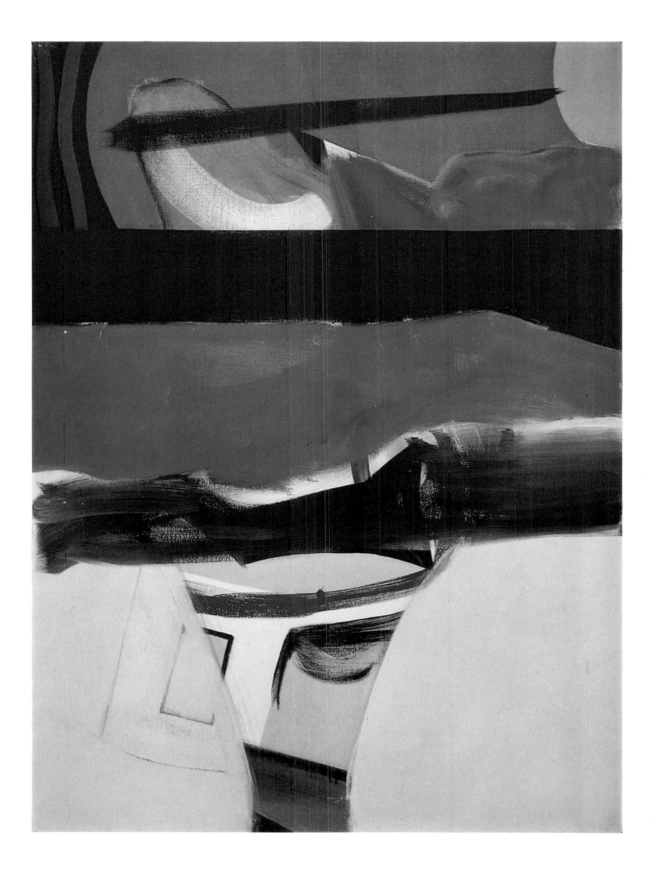

Plate 57 **Clevedon Lake**

Plate 58

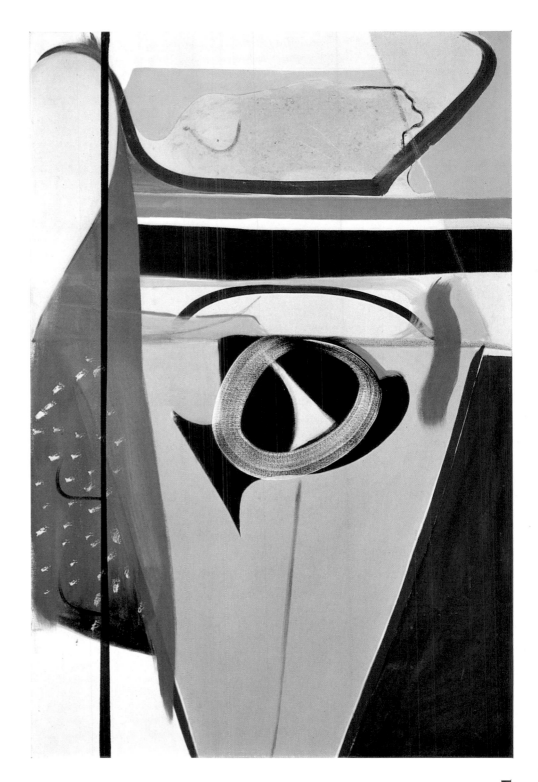

Clevedon Bandstand

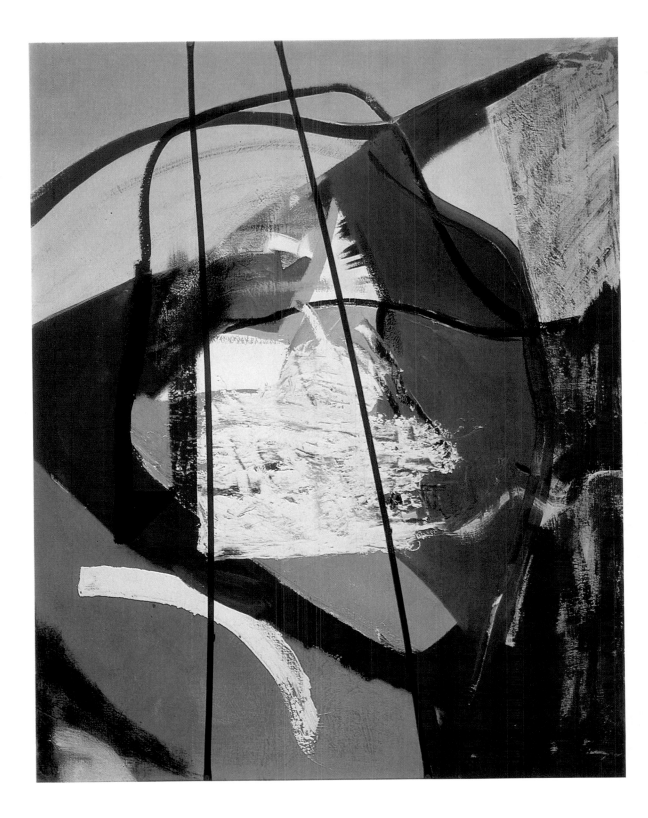

Plate 59

Glide Path

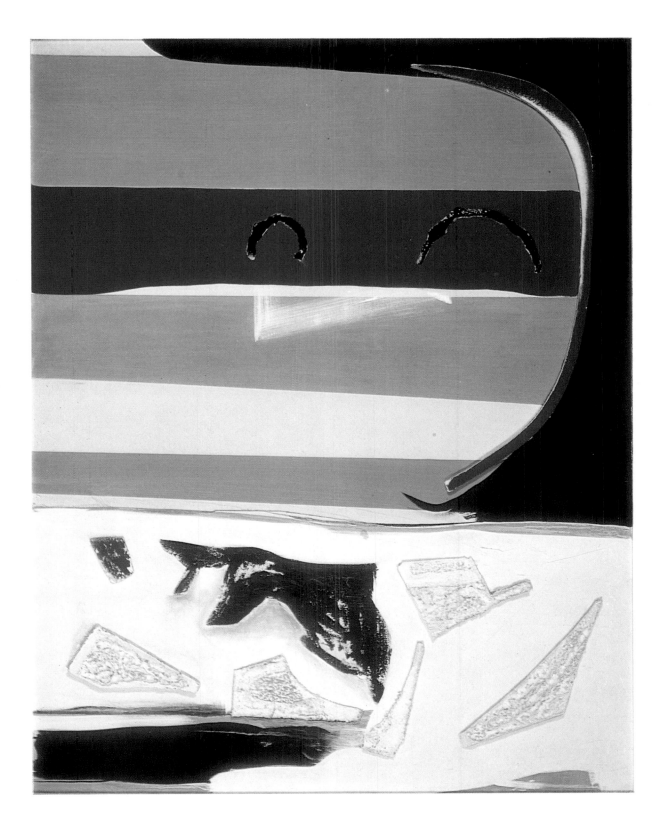

Plate 60

Fistral

Plate 61

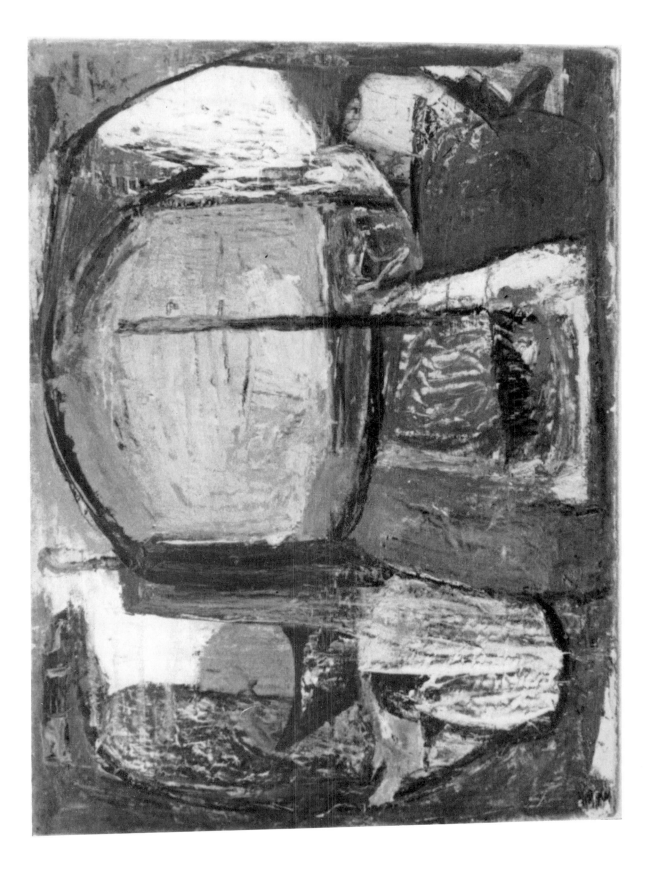

Boulder Coast

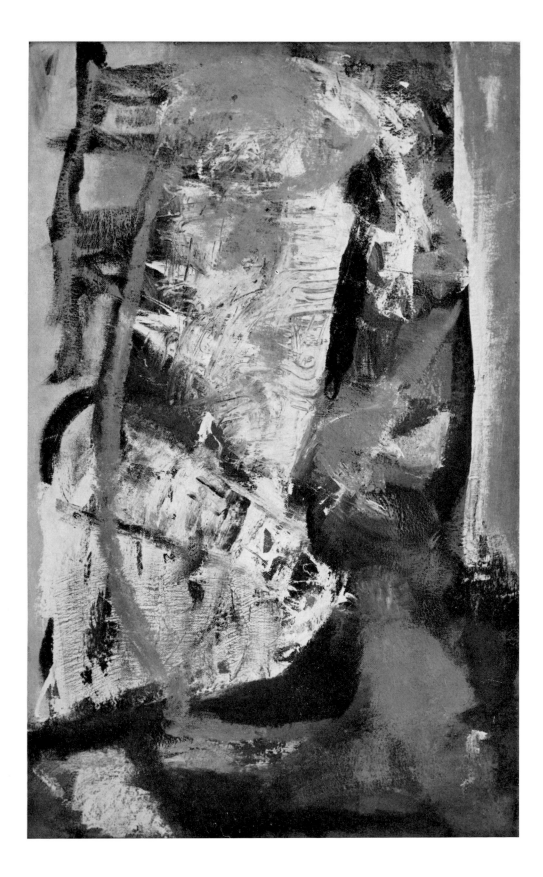

Plate 62

Dry Wind

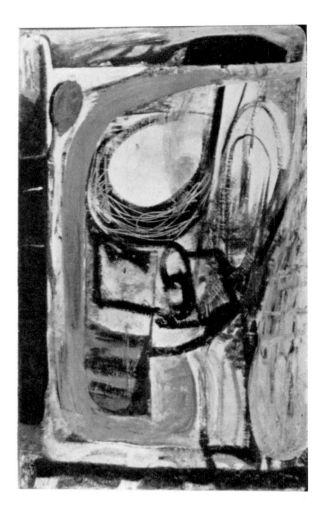

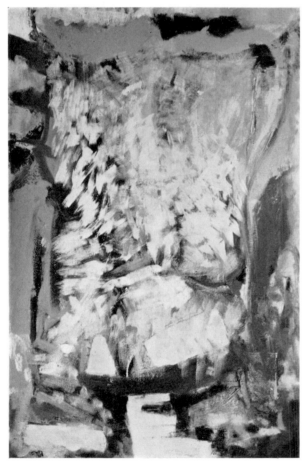

Plate 63

Plate 64

Barley Wind

Lulworth

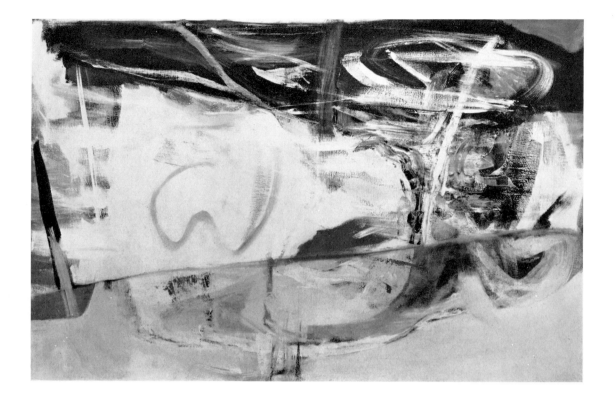

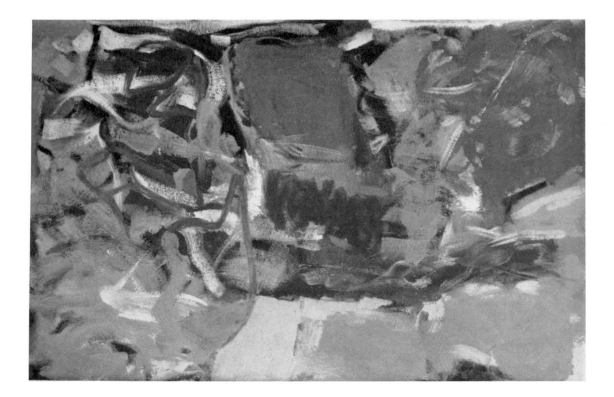

Plate 65 **Cloud Base**

Plate 66 **Harvest Mile**

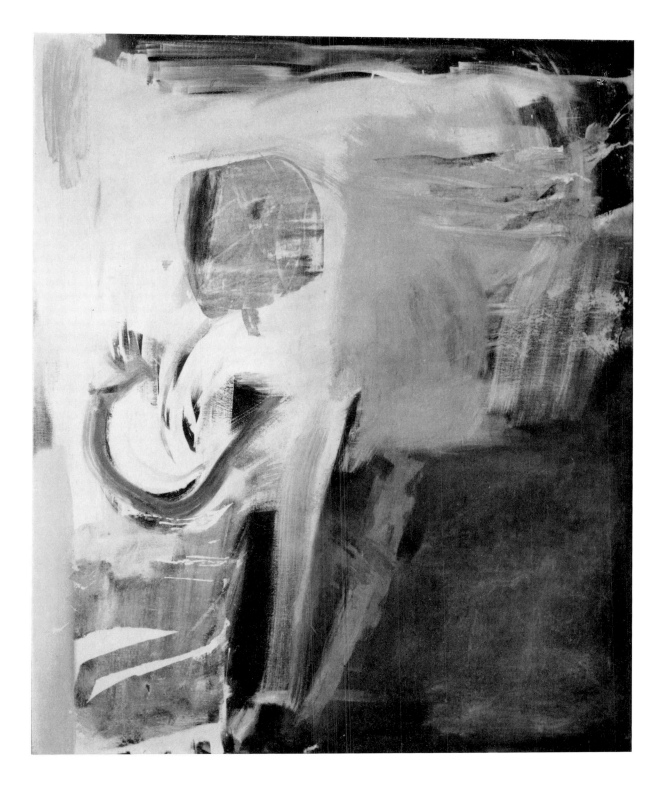

Plate 67

Thermal

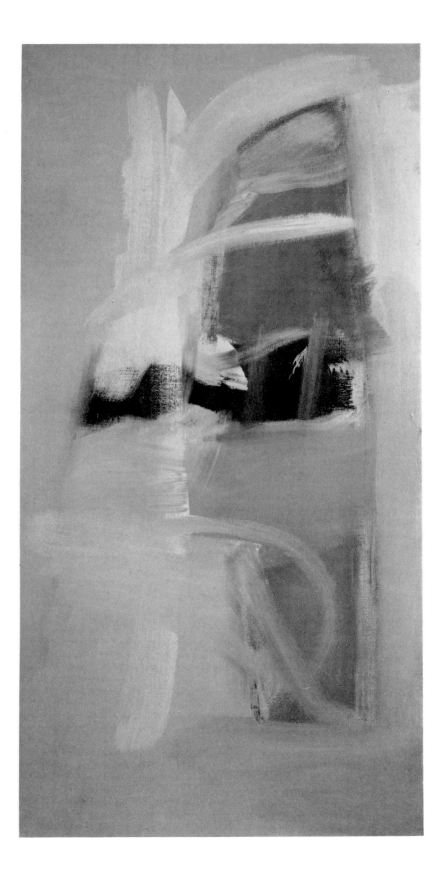

Plate 68 **Low Tide**

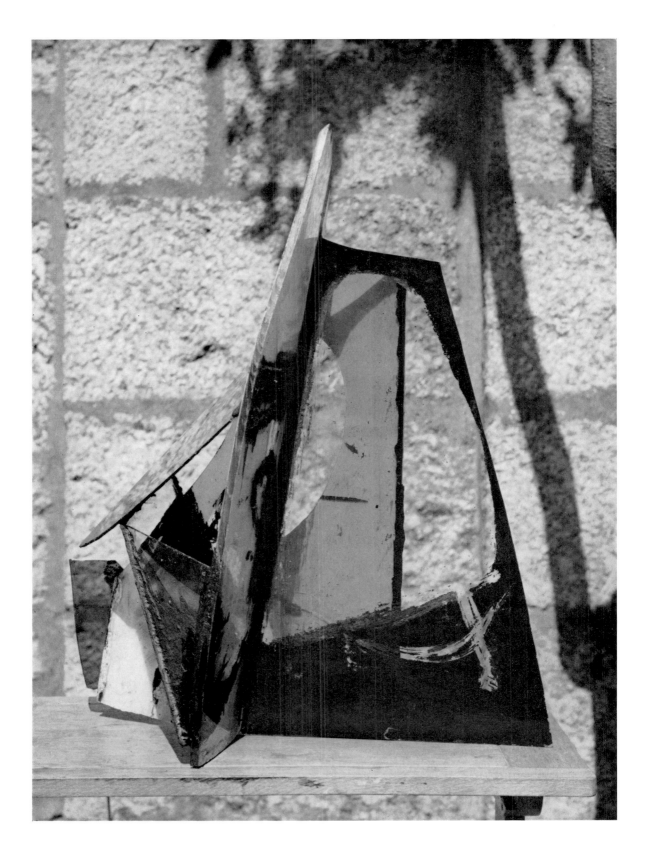

Plate 69

Lost Mine

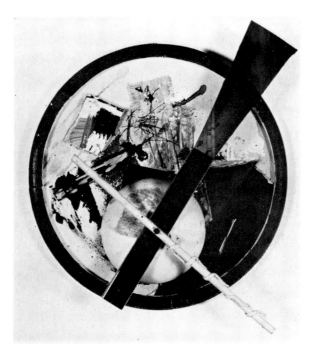

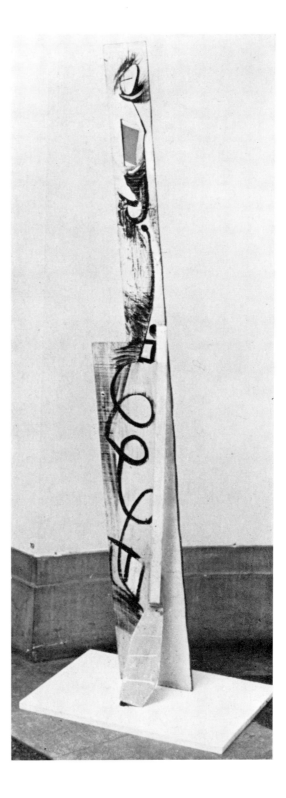

Plate 70 **Crucifixion** *Plate 72* **Tall Country and Seashore**

Plate 71 **Orpheus**

EXHIBITIONS

ONE-MAN

The year given is that in which an exhibition opened.
Some exhibitions, particularly touring shows, continued into the following year.

1949 October 5–29. Lefevre Gallery (23 paintings, 1 drawing)

1951 June 18–30. Downing's Bookshop, St Ives (8 oils, 2 constructions, 6 works on paper)

1952 March. Gimpel Fils (10 paintings, 13 works on paper, 2 screen prints, and some pottery, uncatalogued)

1954 March. Gimpel Fils (13 paintings, 6 gouaches, 6 pottery objects, 1 sculpture)

1955 May 5–30. City Art Gallery, Plymouth (26 paintings, 2 works on paper), subsequently shown at the Midland Group Gallery, Nottingham

1957 January 21–February 9. Catherine Viviano, New York (16 paintings)

1958 March. Gimpel Fils (21 paintings, 4 gouaches, 11 drawings, 2 sculptures, 3 pots)

1959 January 26–February 21. Catherine Viviano, New York (16 paintings)

1960 October 11–November 5. Gimpel Fils (20 paintings, 2 gouaches)

1961 September. VI São Paulo Biennale (12 paintings)

1962 January 30–February 17. Catherine Viviano, New York (14 paintings)

May. Sail Loft Gallery, St Ives (14 works on paper)

October. Gimpel Fils (17 paintings, 4 gouaches)

1963 March. Marion Koogler McNay Art Institute, San Antonio (no catalogue)

April 2–20. Catherine Viviano, New York (1 painting, 9 gouaches)

October 12–November 2. Three Contemporary Painters (with Henry Mundy and Ceri Richards), Arts Council Gallery, Cambridge (8 paintings), subsequently shown at King's Lynn, Glasgow, Nottingham, and Cheltenham

1964 May 5–23. Catherine Viviano, New York (9 paintings, 7 watercolours, 6 collage constructions)

September 17–October 7. Gimpel and Hanover Galerie, Zurich (18 paintings, 8 gouaches)

1968 May 30–June 30. Arts Council Exhibition at the Tate Gallery (78 paintings, 17 constructions), subsequently shown at Plymouth, Newcastle upon Tyne, Birmingham, Liverpool and Newlyn

1969 November 1–22. Bear Lane Gallery, Oxford (30 gouaches, 32 drawings)

1970 April 27–June 5. Sheviock Gallery, Torpoint (10 oils, 10 gouaches, 2 prints, 1 collage)

October 28–November 26. Clevedon Drawings and Gouaches and Paintings. 1964, Arnolfini Gallery, Bristol (4 paintings, 6 gouaches, 7 drawings), subsequently shown at Leeds

1971 June 4–30. Exeter University (9 gouaches, 10 drawings)

MIXED

1946 Crypt Group, St Ives
1947 *Salon des Réalités Nouvelles*, Paris
1949 *Salon des Réalités Nouvelles*, Paris
1950 March–April. London–Paris, Institute of Contemporary Arts
 21 Modern British Painters, British Council exhibition touring United States and Canada
1951 Contemporary British Art, Vancouver
 Abstract Art, New York
 Sixty Paintings for '51, Arts Council exhibition for the Festival of Britain, shown in Manchester, London, etc.
 August. British Abstract Art, Gimpel Fils
1952 May. Seven British Contemporary Artists, Black Hall, St Giles, Oxford
 October. *Tendances de la peinture et de la sculpture britannique contemporaine*, Galerie de France, Paris
1953 West Country Landscape, Arts Council travelling exhibition
 Mixed exhibition, Passedoit Gallery, New York
 May. International Watercolour Exhibition, Brooklyn Museum, New York
 May. Coronation Exhibition, Redfern Gallery
 July. Space in Colour, Hanover Gallery
 November. Figures in their Setting, Contemporary Art Society exhibition at the Tate Gallery
1954 February. Recent British Drawings, Institute of Contemporary Arts
 Recent British Painting, Arts Council travelling exhibition
1955 February. Lanyon, Wynter, Potworowski, Feiler; Octagon, Bath
 October. Pittsburgh International, Carnegie Institute, Pittsburgh
1956 January. Ten Years of English Landscape Painting, Institute of Contemporary Arts
 Six Painters from Cornwall, exhibition touring Canada and the United States
 Contemporary British Art, British Council exhibition touring Denmark and Norway
1957 April. Metavisual Tachiste Abstract, Redfern Gallery
 New Trends in British Art, Rome–New York Art Foundation, Rome
 November. 1st John Moores Exhibition, Walker Art Gallery, Liverpool
 December. Dimensions, O'Hana Gallery
 Young British Painters, Arts Club of Chicago; Albright-Knox Art Gallery, Buffalo; National Gallery of Canada, Ottawa; etc.
1958 Auckland City Art Gallery, New Zealand, British Abstract Painting
 June. Guggenheim Painting Award: British Section, Whitechapel Art Gallery
 June. Abstract Impressionism, University of Nottingham and Arts Council Gallery, London
 Young British Painters, Kunstkring, Rotterdam; Kunstgilde, Zurich; Kunstverein, Düsseldorf
 November. Five Cornish Artists, Bear Lane Gallery, Oxford
 December. Pittsburgh International, Carnegie Institute, Pittsburgh
 The Religious Theme, Contemporary Art Society exhibition at the Tate Gallery
1959 February. 11 British Artists, Jefferson Place Gallery, Washington
 June–October. Documenta 2, Kassel
 Art on the Campus, Brandeis University, Massachusetts

1959 5th International Art Exhibition, Tokyo
November. 2nd John Moores Exhibition, Walker Art Gallery, Liverpool
European Painting and Sculpture Today, Minneapolis Institute of Arts; San Francisco Museum of Art;
National Gallery of Canada, Ottawa; Baltimore Museum of Art; etc.

1960 April–May. The First Fifty Years, 1910–60, Contemporary Art Society exhibition at the Tate Gallery
June. Denys Sutton: Critics' Selection, Arthur Tooth & Son
British Painting 1720–1960, British Council exhibition at the Pushkin Museum, Moscow, and the Hermitage,
Leningrad
Contemporary British Landscape, Arts Council travelling exhibition
October. Mural Art Today, Victoria and Albert Museum
Irish Exhibition of Living Art, Dublin
Modern Stained Glass, Arts Council travelling exhibition

1961 June. Stanley J. Seeger Jr Collection, Princeton University Art Museum
International art exhibition, Tunis
Contemporary British Painting, British Council exhibition touring the Middle East
New Painting 58–61, Arts Council travelling exhibition
October. Pittsburgh International, Carnegie Institute, Pittsburgh

1962 January–March. Primitives to Picasso, Royal Academy
February–April. *Arte Britânica no seculo XX*, British Council exhibition for the Calouste Gulbenkian Foundation,
Lisbon, Coimbra, and Oporto
Premio Marzotto, Valdagno, Vicenza, subsequently shown at Baden-Baden, Eindhoven, Whitechapel, and the
Musée des Arts Décoratifs, Paris
Contemporary British Painting, Blair Laing Gallery, Toronto
October–December. Kompas 2, Contemporary Paintings in London, Stedelijk van Abbe Museum, Eindhoven
November. British Art Today, San Francisco Museum of Art, Dallas Museum of Art and Santa Barbara Museum

1963 June. British Painting in the Sixties, Contemporary Art Society exhibition at the Tate Gallery, subsequently
shown in Zurich, Glasgow, etc.
June. *Ier Salon International de Galeries Pilotes*, Lausanne
British Paintings, 1900–62, British Council exhibition touring eastern Europe
Some Aspects of Contemporary British Painting, British Council exhibition touring the state galleries of Canada;
also shown at Louisiana and in Denmark
Recent British Gouaches, British Council exhibition touring Germany
September. Commonwealth Biennale of Abstract Art, Commonwealth Institute
October. Four Painters, Arnolfini Gallery, Bristol
November. 4th John Moores Exhibition, Walker Art Gallery, Liverpool

1964 Contemporary British Painting and Sculpture, Albright–Knox Art Gallery, Buffalo
April–June. 54:64 Painting and Sculpture of a Decade, Calouste Gulbenkian Foundation exhibition at the
Tate Gallery
April–June. Profile 3, *Englische Kunst der Gegenwart*, Städtische Kunstgalerie, Bochum
May–July. *Englische Malerie der Gegenwart*, Kunstverein, Düsseldorf
November. Pittsburgh International, Carnegie Institute, Pittsburgh

1965 July–December. Corsham Painters and Sculptors, Arts Council touring exhibition
27 Contemporary British Paintings, British Council exhibition touring Mediterranean countries

1967 Il Fiorino exhibition, Florence
November–December. Recent British Painting, Peter Stuyvesant Foundation exhibition at the Tate Gallery

1968 Il Fiorino exhibition, Florence
Contemporary British Painting, British Council exhibition, Zambia

1969 January–February. The British Landscape Tradition in the 20th Century, Camden Arts Centre

1970 November. British Painting and Sculpture, 1960–70, British Council and Tate Gallery joint exhibition at the
National Gallery of Art, Washington

BIBLIOGRAPHY

Artist's Writings, Interviews, etc.

1957 April 29. BBC Third Programme discussion 'Landscape Painting', by Peter Lanyon, Anthony Fry, and Andrew Forge

1961 July. 'Predicament', answers to questions in *London Magazine*

1962 Autumn. 'A Sense of Place', in *Painter and Sculptor*

1963 Illustrated lecture recorded for the British Council, edited by Alan Bowness

1962 May 17. 'Peter Lanyon Talking', recorded by W. J. Weatherby in the *Guardian*

Articles, Catalogue Introductions

1954 March 6. Patrick Heron. 'Peter Lanyon', in *Art News and Review*; also used as introduction for Plymouth catalogue, 1955

1956 February. Patrick Heron, 'Peter Lanyon', in *Arts*, New York

1958 Summer. John Dalton, 'Lanyon Drawings', in *Painter and Sculptor*

1958 October. Elizabeth Trewren, 'Peter Lanyon', in *New Cornwall*, Totnes

1960 April–June. Alan Bowness, 'Peter Lanyon', in *Cimaise*, Paris

1961 J. P. Hodin, 'Artist and Architect', in *Quadrum* 10

1961 Alan Bowness, introduction to São Paulo Biennale catalogue

1962 May 17. John Dalton, 'Lanyon and Landscape', in the *Guardian*

1962 November. John Dalton, 'Lanyon and Landscape', in *The Studio*

1963 Christmas. J. P. Hodin, in *Vingtième Siècle*, Paris

1964 J. P. Hodin, introduction to Zurich catalogue

1964 September 2. Alan Bowness and Patrick Heron, obituary notice in *The Times*

1965 August. J. P. Hodin, 'The Icarus of Cornwall: Peter Lanyon In Memoriam', in *Studio International*

1965 Michael Canney, 'A Tribute to Peter Lanyon', in *Link*, Cheltenham

1966 Spring. Michael Canney, 'Peter Lanyon', in the *Cornish Review* 1

1968 Alan Bowness, introduction to the Arts Council catalogue

Book References

1951 Herbert Read, *Contemporary British Art*, Penguin (2nd ed., 1964)

1955 Patrick Heron, *The Changing Forms of Art*, Routledge

1959 Herbert Read, 'Great Britain', in *Art since 1945*, Thames & Hudson

1962 John Rothenstein, *British Art since 1900*, Phaidon

1965 Bryan Robertson, John Russell, Lord Snowdon, *Private View*, Nelson

1966 Alan Bowness, 'British Art Today', in *Art of Our Time*, Thames & Hudson

BIOGRAPHY

1918	February 8. Born in St Ives, Cornwall, only son of W. H. Lanyon, amateur photographer and musician Educated at St Erbyn's School, Penzance, and Clifton College
1936	Private art tuition from Borlase Smart in St Ives
1936–7	Studied at the Penzance School of Art
1937	Met Adrian Stokes
1937	Travelled to Johannesburg, and to Holland
1938	Studied at the Euston Road School for four months
1938	Summer. Visited Aix-en-Provence
1939	Met Ben Nicholson, Barbara Hepworth, and Naum Gabo, who had moved to St Ives on the outbreak of war in September 1939; private art tuition from Ben Nicholson
1940–5	Served in Royal Air Force as an aero-engine fitter and engine equipment specialist, rank of Corporal, in the Western Desert, Palestine, and Italy. Demobilized in December
1946	April. Married Sheila St John Browne. Six children born between 1947 and 1957
1946–7	Active member of Crypt Group of Artists, St Ives
1948	June. Visited Italy: Florence, Siena, Perugia, Assisi, Pesaro, Urbino, Bologna, Venice
1949	February. Founder-member of Penwith Society of Arts in Cornwall, St Ives (resigned 1950)
1949	October. First one-man exhibition, at the Lefevre Gallery
1950	Began teaching at the Bath Academy of Art, Corsham Court (until 1957)
1953	January–April. Lived in Rome and Anticoli Corrado, on an Italian government scholarship
1953	Elected member of the Newlyn Society of Artists
1954	February. Awarded Critics' Prize, by British section of the International Association of Art Critics
1957–60	Ran art school, St Peter's Loft at St Ives, with Terry Frost and William Redgrave
1957	January. Visited New York for first one-man exhibition there
1957	Visited Italy
1959	January. Visited New York again; also Washington
1959	November. Awarded a second prize, 2nd John Moores Exhibition
1959	Began gliding
1960	Stained glass construction commissioned by the Arts Council
1960	May. Completed ceramic mural for Civil Engineering Building, University of Liverpool (architect, Maxwell Fry)
1960–1	Visiting lecturer, Falmouth School of Art
1960–4	Visiting lecturer, West of England College of Art, Bristol
1961	Chairman, Newlyn Society of Artists, Cornwall
1961	Elected Bard of Cornish Gorsedd for services to Cornish art
1962	January 25–February 10. Visited New York: mural commissioned for house of Stanley J Seeger, Jr. Frenchtown, New Jersey (completed in July)
1962	June. Short visit to New York
1962	September. Given a Marzotto Acquisition Award
1963	February 24–April 10. Visiting Painter, San Antonio Art Institute, Texas. Visited Mexico
1963	September. Completed mural painting for Arts Building, University of Birmingham
1963	October. Member of Jury, 4th John Moores Exhibition
1964	February. Visited Prague and Bratislava to lecture for British Council
1964	August 31. Died at Taunton, as a result of injuries received in a gliding accident in Somerset on August 27

ILLUSTRATED CONSTRUCTIONS AND OTHER WORKS

(Other than White Track and Construction,
the following works, although not discussed
in the text, are shown to give an illustrated
background to the paintings.)

CONSTRUCTIONS

White Track 1939–40 *Plate 25*

Relief construction of wood, cardboard, and string, $17\frac{1}{2} \times 19\frac{1}{2}$
Exhibited: Arts Council, 1968 (6)
Collection: Sheila Lanyon

Construction 1947 *Plate 8*

Plywood and aluminium, $10 \times 12 \times 10$
Exhibited: Arts Council, 1968 (12)
Collection: Sheila Lanyon

Tall Country and Seashore 1950 *Plate 72*

Construction for *Porthleven*, *Plate 27*. Jarra wood and plastic, painted, $70 \times 8 \times 8$
Exhibited: Arts Council, 1968 (19)
Collection: Trustees of the Tate Gallery

Construction for Bojewyan Forms 1951 *Plate 14*

Working model for *Bojewyan Farms*, *Plate 28*. Glass, plastic, metal, wood,
masonite, ceramic and Bostick, $19\frac{1}{2} \times 10\frac{1}{2} \times 17$
Exhibited: Arts Council, 1968 (24)
Collection: Sheila Lanyon

Lost Mine 1959 *Plate 69*

Construction for *Lost Mine*, *Plate 45*. Glass construction, $21 \times 17 \times 8$
Collection: Sheila Lanyon

Orpheus 1961 *Plate 71*

Relief construction for *Orpheus*, *Plate 46*. Paint, glass, metal, ceramic tile,
wire on a circular wooden base, $14 \times 14 \times 3\frac{1}{4}$
Exhibited: Arts Council, 1968 (66)
Collection: Sheila Lanyon

DRAWINGS

Anticoli Corrado 1957 *Plate 77*

20 × 16
Collection: Sheila Lanyon

Ilfracombe 1957 *Plate 78*

9 × 13
Collection: Sheila Lanyon

Young Girl 1959 *Plate 80*

14½ × 20
Collection: Basil Jacobs Fine Art Ltd.

Three Nudes 1960 *Plate 79*

22 × 30
Collection: Basil Jacobs Fine Art Ltd.

Clevedon Study No. 4 1964 *Plate 75*

15½ × 19½
Collection: Friends of Bristol Art Gallery

Clevedon Study No. 5 1964 *Plate 76*

15½ × 19½
Collection: E. Lowe

GOUACHES

Crucifixion 1952 *Plate 70*

29 × 21¼
Collection: Basil Jacobs Fine Art Ltd.

Falling Bird 1963 *Plate 73*

22 × 30
Collection: Sheila Lanyon

Crantock 1964 *Plate 74*

22 × 30
Collection: Sheila Lanyon

PUBLIC COLLECTIONS

Great Britain

Arts Council of Great Britain, London
Arts Council of Northern Ireland, Belfast
British Council, London
Cecil Higgins Museum, Bedford
City Museum and Art Gallery, Birmingham
City Museum and Art Gallery, Plymouth
Contemporary Art Society, London
Ferens Art Gallery, Kingston upon Hull
Friends of Bristol Art Gallery, Dyer Bequest
Glynn Vivian Art Gallery, Swansea
Norfolk Contemporary Art Society
Peter Stuyvesant Foundation, London
Portsmouth Education Committee
Russell-Cotes Art Gallery, Bournemouth
Tate Gallery, London
Victoria and Albert Museum, London
Whitworth Art Gallery, University of Manchester

United States

Albright-Knox Art Gallery, Buffalo
Carnegie Institute, Pittsburgh
Cleveland Museum of Art
Princeton University, Art Museum
Smith College Museum of Art, Massachusetts
Yale University Art Gallery

General

Art Gallery of South Australia, Adelaide
Art Gallery of Victoria, Melbourne
Art Gallery of Ontario, Toronto
Calouste Gulbenkian Foundation, Lisbon
National Gallery of Canada, Ottawa
Narodni Gallery, Prague

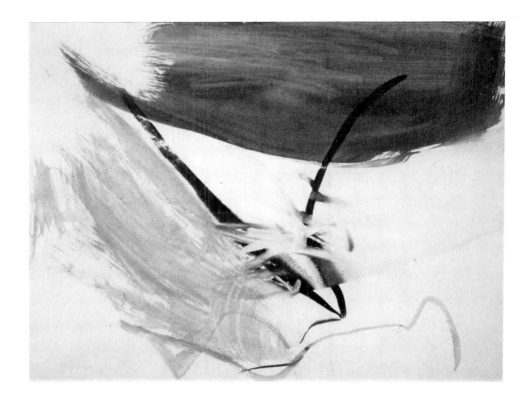

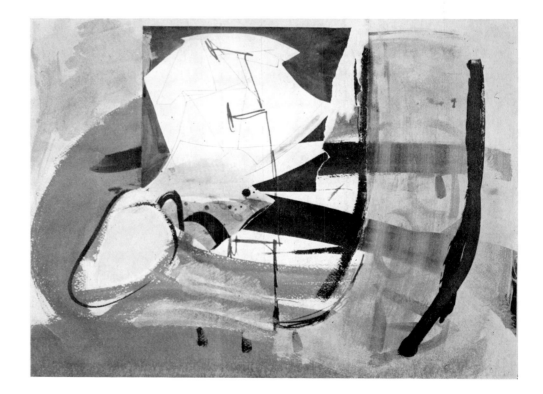

Plate 73 **Falling Bird**

Plate 74 **Crantock**

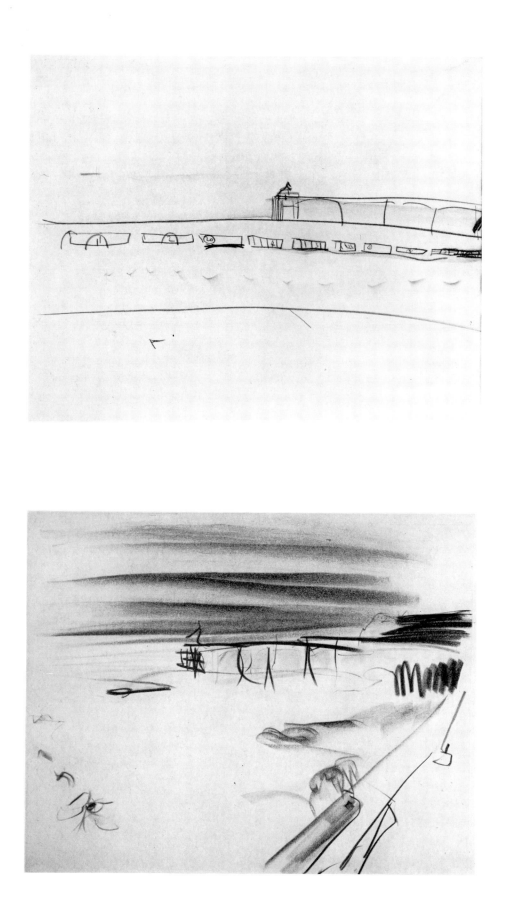

Plate 75 **Clevedon Study No.4**

Plate 76 **Clevedon Study No.5**

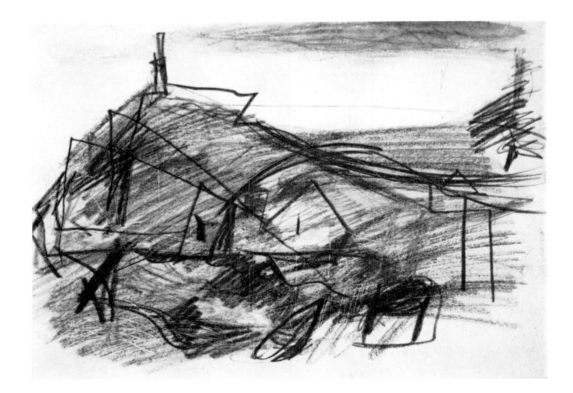

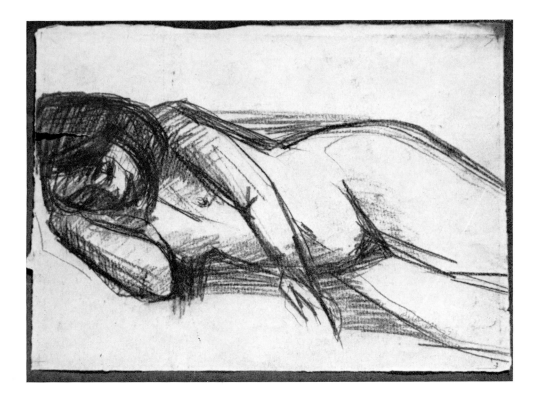

Plate 79 **Three Nudes**

Plate 80 **Young Girl**

CATALOGUE – including oils illustrated

The catalogue lists all Lanyon's traceable paintings from 1945, apart from a
few personal portraits and pictures from the later years where the larger dimensions
are less than 10 inches. Measurements are given in inches, height before width.
Cornish exhibitions are recorded only when it was the first time a picture
was shown. The full titles of exhibitions will be found in the lists of
exhibitions. References are given to reproductions in newspapers only when
none is available in a book, catalogue, or magazine.

1945

1 Black Form
Wax on board, $8\frac{1}{2} \times 7$
Exhibited: Lefevre Gallery, 1949 (41)
Arts Council, 1968 (7)
Collection: Sheila Lanyon

2 Blue Shrine
Oil on board, $11\frac{1}{2} \times 7\frac{1}{2}$
Exhibited: Crypt Group, St Ives, 1946
Collection: Andrew Lanyon

3 Green Form
Oil on paper, $15 \times 10\frac{1}{2}$
Collection: Sheila Lanyon

4 Pink Form
Wax on board, $6\frac{1}{2} \times 8\frac{1}{2}$
Exhibited: Downing's Bookshop, St Ives, 1947 (10)
Collection: John Wells

5 Ruins at Capua *Plate 3*
Oil on board, $11\frac{1}{2} \times 9$
Exhibited: Crypt Group, St Ives, 1946 (74)
Collection: Sheila Lanyon

1946

6 Dance of a Glass Jug
Oil on board, $15\frac{1}{2} \times 11\frac{1}{2}$
Exhibited: Crypt Group, St Ives, 1946 (86)
Collection: Private – London

7 Earth
Oil on board, $16\frac{1}{2} \times 25$
Collection: Sheila Lanyon

8 Fishboat
Oil on board, $5\frac{1}{2} \times 21$
Collection: Private – England

9 Generator *Plate 13*
Oil on canvas, 30×20
Exhibited: Crypt Group, St Ives, 1946 (79)
Arts Council, 1968 (8)
Illustrated: *Studio*, October 1948
Collection: Sheila Lanyon

10 Landscape with Cup (Annunciation) *Plate 5*
Oil on board, $12\frac{1}{2} \times 15\frac{1}{2}$
Exhibited: Crypt Group, St Ives, 1947 (63)
Collection: Sheila Lanyon

11 Trip round the Lighthouse

Oil on board, 20 × 23
Exhibited: Crypt Group, St Ives, 1946 (82)
Collection: Sheila Lanyon

12 The Yellow Runner
Plate 26

Oil on board, 18½ × 24
Exhibited: Crypt Group, St Ives, 1946
Arts Council, 1968 (9)
Collection: Sheila Lanyon

1947
13 Construction in Green
Plate 6

Oil on board, 11¾ × 16
Exhibited: Crypt Group, St Ives, 1948 (47)
Lefevre Gallery, 1949 (44)
Arts Council, 1968 (13)
Collection: Sheila Lanyon

14 Generation
Plate 10

Oil on plywood, 34½ × 13¼
Exhibited: Crypt Group, St Ives, 1947 (65)
Salon des Réalités Nouvelles, Paris, 1949
Lefevre Gallery, 1949 (47)
Plymouth, 1955 (1)
Arts Council, 1968 (14), illustrated in catalogue
Collection: Sheila Lanyon

15 Morvah Chapel

Oil on board, 6 × 9
Exhibited: Crypt Group, St Ives, 1947 (73)
Collection: Lady Mander

16 Prelude
Plate 7

Oil on canvas, 24 × 38
Exhibited: Crypt Group, St Ives, 1947 (61)
Lefevre Gallery, 1949 (46)
Plymouth, 1955 (25)
Arts Council, 1968 (11)
Collection: Sheila Lanyon

17 Sleeping Boat

Wax on card, 18 × 11½
Exhibited: Crypt Group, St Ives, 1947 (52)
Lefevre Gallery, 1949 (43)
Collection: Mrs Eric Thomas

18 Tinstone
Plate 4

Wax on board, 13 × 16
Exhibited: Salon des Réalités Nouvelles, Paris, 1947
Lefevre Gallery, 1949 (45)
Arts Council, 1968 (10)
Collection: Basil Jacobs Fine Art Ltd.

1948

19 Godolphin

Oil on board, 10 × 14
Collection: L. Brook

20 Green Coast

Oil on board, 8 × 16
Exhibited: Lefevre Gallery, 1949 (57)
Hanover Gallery, 1953 (36)
Collection: Patrick Heron

21 Headland

Oil on board, 30 × 20
Exhibited: Crypt Group, St Ives, 1948 (51)
Lefevre Gallery, 1949 (50)
Plymouth, 1955 (5)
Collection: Eve Capon

22 Isis

Oil on board, 11 × 8
Exhibited: Lefevre Gallery, 1949 (53)
Collection: Sheila Lanyon

23 The Yellow Boat *Plate 9*

Oil on board, 15 × 19
Exhibited: Lefevre Gallery, 1949 (55)
Arts Council, 1968 (15)
Illustrated: *Painter and Sculptor*, autumn 1962
Cornish Review, spring 1966
Collection: Lawrence Ogilvie

1949

24 Cape Family *Plate 12*

Oil on masonite, 72 × 48
Exhibited: Lefevre Gallery, 1949 (64)
Institute of Contemporary Arts, 1950 (53)
Plymouth, 1955 (2)
Arts Council, 1968 (17)
Illustrated: *Meta 5*, March 1951
Collection: Sheila Lanyon

25 Cliff Walk

Gouache and wax on board, 21 × 11½
Exhibited: Plymouth, 1955 (6)
Collection: Mrs S. Zucker

26 Godolphin

Oil on masonite, 12 × 6
Exhibited: Lefevre Gallery, 1949 (59)
Collection: Lady Mander

27 Godrevy Lighthouse

Oil on masonite, $20\frac{1}{2} \times 10\frac{1}{2}$
Exhibited: Lefevre Gallery, 1949 (62)
Institute of Contemporary Arts, 1950 (52)
Collection: Private – Rome

28 North

Oil on masonite, 16×8
Exhibited: Lefevre Gallery, 1949 (58)
Black Hall, Oxford, 1952 (7)
Collection: Mrs T. Early

29 Portreath *Plate 11*

Oil on strawboard, 20×16
Exhibited: Penwith Society of Arts first exhibition,
1949 (55)
Lefevre Gallery, 1949 (61), illustrated in catalogue
Plymouth, 1955 (4)
Arts Council, 1968 (18), illustrated in catalogue
Collection: Capt. Ernan Forbes Dennis

30 West Penwith

Oil on plywood, $11\frac{1}{2} \times 43$
Exhibited: Penwith Society of Arts first exhibition,
1949 (66)
Lefevre Gallery, 1949 (60)
Institute of Contemporary Arts, 1950 (51)
Vancouver, 1951
Arts Council, 1953 (17)
Arts Council, 1954 (26)
Plymouth, 1955 (3)
Bath, 1955 (3)
The Minories, Colchester, The Rosenberg Collection,
June 1964
Arts Council, 1968 (16)
Collection: Eugene Rosenberg

1950

31 Carthew

Oil on masonite, 8×16
Exhibited: Institute of Contemporary Arts, 1950 (54)
Gimpel Fils, 1951
Illustrated: *The Listener*, August 9, 1951
Collection Mrs J. May

32 Little Bracken

Oil on board, 12×8
Exhibited: Black Hall, Oxford, 1952 (8)
Gimpel Fils, 1952 (19)
Collection: Private

33 White Boat

Oil on masonite, 12×18
Exhibited: Hanover Gallery, 1953 (35)
Plymouth, 1955 (7)
Collection: Charles Gimpel

34 White Boat Leaving
Oil on masonite, $6\frac{1}{2} \times 7\frac{1}{2}$
Collection: Roger Hilton

35 Zennor Bird
Oil on masonite, 8×16
Exhibited: Sail Loft Gallery, St Ives, 1962 (19)
Collection: Peter Gimpel

1951

36 Bicyclist in Penwith *Plate 19*
Oil on masonite, 18×6
Exhibited: Gimpel Fils, 1952 (21)
Arts Council touring exhibition, 1957
British Painting 1950–57 (21)
Collection: Arts Council of Great Britain

37 Bodmin Moor
Oil on masonite, 15×4
Collection: Frank Walker

38 Corsham Towers *Plate 16*
Oil on masonite, 24×4
Exhibited: Gimpel Fils, 1952 (20)
Collection: Frank Walker

39 Godrevy
Oil on masonite, 14×12
Exhibited: Gimpel Fils, 1954 (4)
Collection: Frank Walker

40 Green Landscape, Trevalgan
Oil on masonite, 48×48
Exhibited: Gimpel Fils, 1952 (2)
Black Hall, Oxford, 1952 (12)
Galerie de France, Paris, 1952
Bath, 1955 (6)
Plymouth, 1955 (9)
Illustrated: *Vogue*, February 1952
Collection: Estate of Tom Slick

41 Porthleven *Plate 27*
Oil on masonite, 96×48
Exhibited: Arts Council, Sixty Paintings for '51, 1951 (29),
illustrated in catalogue
Tate Gallery, Contemporary Art Society, The First Fifty
Years, 1960 (39)
Arts Council, 1968 (21), illustrated in catalogue
Illustrated: *Painter and Sculptor*, autumn 1962
Studio, August 1965
Collection: Trustees of the Tate Gallery (gift of the
Contemporary Art Society)

42 St Just
Oil on canvas, 96 × 48
Exhibited: Hanover Gallery, 1953 (34)
Gimpel Fils, 1954 (10)
Plymouth, 1955 (13)
Arts Council, 1968 (23), illustrated in catalogue in colour
Illustrated: *Arts Digest*, March 15, 1955
Arts (New York), February 1956
Collection: Sheila Lanyon

Plate 1

43 Trencrom Hill
Oil on masonite, 36 × 24
Exhibited: Downing's Bookshop, St Ives, 1951 (9)
Pittsburgh International, 1955 (164)
O'Hana Gallery, 1957 (40)
Auckland City Art Gallery, New Zealand, British
Abstract Painting, May 1958 (46)
Arts Council, 1960–61 (30)
Illustrated: *Glasgow Herald*, March 6, 1961
Collection: Private

1952

44 Bojewyan Farms
Oil on masonite, 48 × 96
Exhibited: Gimpel Fils, 1952 (1)
Gimpel Fils, Summer Exhibition, 1952 (20), illustrated
in catalogue
Plymouth, 1955 (8)
Arts Council, 1960–61 (32)
Arts Council, 1968 (25)
Collection: British Council

Plate 28

45 Botallack
Oil on masonite, 50 × 16
Exhibited: Gimpel Fils, 1952 (4), illustrated cover of
catalogue
Collection: Art Gallery of Ontario, Toronto

Plate 18

46 Boulder Coast
Oil on masonite, 36 × 48½
Exhibited: Passedoit Gallery, New York, 1953
Bath, 1955 (?), as *Boulder Cliff*
Plymouth, 1955 (?), as *Boulder Cliff*
British Council, 1961
Tate Gallery, 1968 (26)
Collection: Alan Bowness

Plate 61

47 Cape Wind
Oil on masonite, 51 × 25
Exhibited: Galerie de France, Paris, 1952
Gimpel Fils, 1954 (1)
Plymouth, 1955 (12)
Catherine Viviano, New York, 1957 (3)
Chicago, 1957 (14)
Collection: Catherine Viviano

Plate 17

48 Corsham Summer *Plate 20*

Oil on masonite, 72 × 24
Exhibited: Bath, 1955 (5)
Plymouth, 1955 (27)
Copenhagen, 1956 (47), as *Vertical Landscape, Corsham*
Catherine Viviano, New York, 1957 (1)
Chicago, 1957 (13)
Marion Koogler McNay Art Institute, San Antonio, 1963
Illustrated: *Arts* (New York), February 1956, as *Vertical Landscape, Corsham*
Collection: Catherine Viviano

49 Cut Corn

Oil on masonite, 13¼ × 21¾
Exhibited: Hanover Gallery, 1953
Collection: Smith College Museum of Art,
Northampton, Massachusetts

50 Farm Backs *Plate 2*

Oil on masonite, 41 × 28
Exhibited: Passedoit Gallery, New York, 1953
British Embassy, Brussels, 1958 (7)
Arts Council, 1960–61 (31)
Arts Council, 1968 (27)
Illustrated: *A Dictionary of Modern Art*, by Herbert Read, 1968
Collection: Sheila Lanyon

51 Green Mile *Plate 29*

Oil on masonite, 62½ × 19½
Exhibited: Galerie de France, Paris, 1952
London Group, 1953 (139)
Arts Council, 1954 (27)
Plymouth, 1955 (11)
Arts Council, 1968 (28)
Illustrated: *Arts* (New York), February 1956
Collection: Bishop Otter College, Chichester

52 Harvest Festival *Plate 15*

Oil on masonite, 72 × 24
Exhibited: Redfern Gallery, Coronation Exhibition, 1953 (132)
Bath, 1955 (4)
Plymouth, 1955 (10)
Copenhagen, 1956 (46)
Smithsonian Institution, 1958
Collection: Sheila Lanyon

53 Inland Water

Oil on masonite, 20 × 22½
Exhibited: Gimpel Fils, 1952 (9)
Catherine Viviano, New York, 1957 (2)
Collection: Rev. Robert Hunsicker

54 Inshore Fishing

Oil on masonite, 42 × 29
Exhibited: Bath, 1955 (2)
Plymouth, 1955 (15)
O'Hana Gallery, 1957 (41)
Collection: Private

55 Levant Old Mine

Oil on masonite, 51 × 47
Exhibited: Gimpel Fils, 1952 (3)
Collection: Private – London

1953

56 Anticoli Snow

Oil on masonite, 48 × 20
Collection: Frank Walker

57 Study for Europa

Oil on masonite, 12 × 22
Collection: Sheila Lanyon

58 Façade

Oil on masonite, 10 × 14
Exhibited: Gimpel Fils, 1954 (13)
Collection: Miss H. Church

59 Greystone

Oil on board, 10 × 14
Exhibited: Gimpel Fils, 1954 (8)
Collection: C. Maggs

60 Judy

Oil on masonite, 27 × 16½
Exhibited: Gimpel Fils, 1954 (5)
Plymouth, 1955 (20)
Collection: Linden Travers

61 Levant Zawn

Oil on masonite, 33½ × 27
Exhibited: Arts Council, 1953 (35)
Plymouth, 1955 (16)
Tate Gallery, 1968 (29)
Illustrated: *Liverpool Evening Express*, April 15, 1954
Collection: Gimpel Fils

62 Primavera *Plate 24*

Oil on masonite, 28 × 28
Exhibited: Gimpel Fils, 1954 (6)
Arts Council, 1968 (30)
Exeter, 1971 (27)
Collection: Basil Jacobs Fine Art Ltd.

63 Via Tiber, Rome

Oil on masonite, 14 × 18
Exhibited: Gimpel Fils, 1954 (12)
Collection: Miss J. Wright

1954

64 Blue Boat and Rainstorm

Oil on masonite, 48 × 57
Exhibited: Whitechapel Art Gallery, 1954 (35)
Plymouth, 1955 (19)
Illustrated: *Arts* (New York), February 1956
Collection: Mark Moyens

65 Europa *Plate 32*

Oil on masonite, 48 × 72
Exhibited: Plymouth, 1955 (21)
Copenhagen, 1956 (48)
Catherine Viviano, New York, 1957 (4)
Chicago, 1957 (17)
Princeton University Art Museum, 1961 (98)
Arts Council, 1968 (36), illustrated in catalogue
Collection: Stanley J. Seeger Jr

66 Moor Cliff, Kynance *Plate 21*

Oil on masonite, 51 × 27
Exhibited: Gimpel Fils, 1954 (7)
Plymouth, 1955 (14)
Arts Council, 1968 (31)
Collection: Arts Council of Great Britain

67 Mullion Bay

Oil on masonite, 60 × 60
Exhibited: Gimpel Fils, 1954 (2)
Awarded the Critics' Prize, 1954
Illustrated: *Architectural Review*, June 1954
Collection: National Gallery of Victoria, Melbourne
(Felton Bequest)

68 Nude in Black

Oil on masonite, 12½ × 18
Exhibited: Sail Loft Gallery, St Ives, 1962 (25)
Collection: Private – Cornwall

69 Saracinesco *Plate 30*

Oil on masonite, 50 × 48
Exhibited: Gimpel Fils, 1954 (3)
Plymouth, 1955 (18)
Arts Council, 1968 (32)
Illustrated: *Studio*, November 1962
Collection: City Museum and Art Gallery, Plymouth

1955

70 Bird Wind
Oil on masonite, 42 × 30
Exhibited: Plymouth, 1955 (22)
Collection: W. M. Roth

1956

71 Anticoli
Oil on masonite, 47 × 8¼
Exhibited: Gimpel Fils, 1958 (16)
Princeton University Art Museum, 1961 (102),
illustrated in catalogue
Arts Council, 1968 (37)
Collection: Stanley J. Seeger Jr.

72 Boscastle
Oil on masonite, 47½ × 47½
Exhibited: Catherine Viviano, New York, 1957 (8)
Providence, Rhode Island, A Collection in the Making,
1959
Arts Council, 1968 (41)
Collection: Richard Brown Baker

73 Dorset Coast
Oil on masonite, 23½ × 30
Exhibited: Catherine Viviano, New York, 1957 (6)
Collection: Robert Millonzi

74 Downland
Oil on masonite, 47½ × 23½
Exhibited: Catherine Viviano, New York, 1957 (16)
Collection: Mrs Van Merle Smith

75 High Ground
Oil on masonite, 48 × 72
Exhibited: Catherine Viviano, New York, 1957 (13)
Arts Council, 1968 (39)
Collection: Franklin Kissner

76 Lea Cliff
Oil on masonite, 48 × 72
Exhibited: Catherine Viviano, New York, 1957 (12)
Marion Koogler McNay Art Institute, San Antonio, 1963
Arts Council, 1968 (40)
Collection: Catherine Viviano

77 Lulworth *Plate 64*
Oil on masonite, 72 × 48
Exhibited: Catherine Viviano, New York, 1957 (5)
Marion Koogler McNay Art Institute, San Antonio, 1963
Illustrated: Albright-Knox *Gallery Notes*, spring 1970
Collection: Albright-Knox Art Gallery, Buffalo

78 Rain

Oil on masonite, 49 × 18
Exhibited: Catherine Viviano, New York, 1957 (10)
Collection: Samuel Rosenman

79 Sandbar

Oil on masonite, 72 × 48
Exhibited: Catherine Viviano, New York, 1957 (14)
Chicago, 1957, illustrated in catalogue
Illustrated: *British Art since 1900*, by John Rothenstein,
1962, p.153
Collection: Thomas Adler

80 Sky

Oil on masonite, 46 × 36
Exhibited: Catherine Viviano, New York, 1957 (15)
Albright-Knox Art Gallery, Buffalo, Contemporary
British Painting and Sculpture, 1964 (25)
Collection: Seymour Knox

81 Tall Summer Country

Oil on masonite, 72 × 30
Exhibited: Catherine Viviano, New York, 1957 (9)
Arts Council, 1968 (38)
Collection: Albright-Knox Art Gallery, Buffalo

82 Tamarisk *Plate 37*

Oil on masonite, 48 × 36
Exhibited: Catherine Viviano, New York, 1957 (7),
illustrated in catalogue
British Council, 1961 (12)
Arts Council, 1963–4 (1)
Arts Council, 1968 (42)
Collection: Gimpel Fils

83 Tide Race

Oil on masonite, 33 × 28
Exhibited: Chicago, 1957 (18)
Arts Council, 1965 (121)
Collection: Private – U.S.A.

84 Tree Top Nest

Oil on masonite, 48 × 30
Exhibited: Catherine Viviano, New York, 1957 (11)
Marion Koogler McNay Art Institute, San Antonio, 1963
Collection: Catherine Viviano

1957

85 Beach

Oil on masonite, 24 × 18
Exhibited: Gimpel Fils, 1958 (19)
Collection: A.D. Emil

86 Coast Wind

Oil on masonite, 72 × 48
Exhibited: Gimpel Fils, 1958 (3)
5th International Art Exhibition, Tokyo, 1959
Gimpel Fils, 1960 (4)
Kompas 2, Eindhoven, 1962 (46)
Arts Council, 1963–4 (2)
Arts Council, 1968 (45)
Illustrated: *Art since 1945*, by Herbert Read, 1959, pl.116
in colour
Collection: Private – Cornwall

87 Green End

Oil on masonite, 10 × 1½
Exhibited: Gimpel Fils, 1958 (14)
Collection: Basil Taylor

88 Gull Shore

Oil on masonite, 48 × 72
Exhibited: Gimpel Fils, 1958 (1), illustrated in catalogue
Nottingham, 1958 (17), illustrated in catalogue
Marion Koogler McNay Art Institute, San Antonio, 1963
Collection: Estate of Tom Slick

89 High Field

Oil on masonite, 31½ × 21½
Exhibited: Gimpel Fils, 1958 (5)
Collection: City Museum and Art Gallery, Plymouth (gift
of the Contemporary Art Society)

90 Landscape with Cross

Oil on masonite, 72 × 30
Exhibited: Rome–New York Art Foundation, Rome, 1957
(16), illustrated in catalogue
Catherine Viviano, New York, 1959 (1)
North American touring exhibition, 1959–60 (57),
illustrated in catalogue
Collection: Bruce Dayton

91 Lynmouth

Oil on masonite, 72 × 48
Exhibited: Rome–New York Art Foundation, Rome, 1957 (15)
Pittsburgh International, 1958 (256)
Collection: Carnegie Institute permanent collection

92 St Ives Bay *Plate 22*

Oil on masonite, 48 × 72
Exhibited: 1st John Moores Exhibition, Liverpool, 1957
(92)
Chicago, 1957 (30)
5th International Art Exhibition, Tokyo, 1959, illustrated
in catalogue
Guggenheim International, 1959
Collection: Private – London

93 Silent Coast *Plate 38*

Oil on masonite, 48 × 36
Exhibited: Gimpel Fils, 1958 (2)
Guggenheim Award, Whitechapel Art Gallery, 1958
Documenta 2, Kassel, 1959
Kompas 2, Eindhoven, 1962 (47)
Lausanne, 1963 (143), illustrated in catalogue
Arts Council, 1968 (44), illustrated in catalogue
Collection: Gimpel Fils

94 Straw Wind, Anticoli

Oil on masonite, 47 × 19½
Exhibited: Chicago, 1957 (20)
Collection: Catherine Viviano

1958

95 Abbotsbury Susan

Oil on masonite, 32 × 8½
Exhibited: Princeton University Art Museum, 1961 (99),
illustrated in catalogue
Collection: Stanley J. Seeger Jr.

96 Albano

Oil on masonite, 32 × 8½
Exhibited: Gimpel Fils, 1958 (10)
Collection: W. E. Tucker

97 Barley Wind *Plate 63*

Oil on Masonite, 72 × 48
Exhibited: Catherine Viviano, New York, 1959 (8)
Arts Council, 1968 (49)
Collection: Margaret Viviano

98 Bay Wind

Oil on masonite, 72 × 48
Exhibited: Catherine Viviano, New York, 1959 (6)
Brandeis University, Massachusetts, Art on the Campus,
1959
Marion Koogler McNay Art Institute, San Antonio, 1963
Collection: Catherine Viviano

99 Black Country

Oil on masonite, 52 × 48
Exhibited: Catherine Viviano, New York, 1959 (14)
Marion Koogler McNay Art Institute, San Antonio, 1963
Collection: Catherine Viviano

100 Calvary

Oil on masonite, 72 × 48
Exhibited: Tate Gallery, 1958 (25)
Irish Exhibition of Living Art, Dublin, 1960 (68)
São Paulo Biennale, 1961 (1)
Midland Group Gallery 21st birthday exhibition,
Nottingham, 1963 (6)
Collection: Private – England

101 Cliff Pool

Oil on masonite, 72 × 48
Exhibited: Catherine Viviano, New York, 1959 (3)
Illustrated: *Yale Art Gallery Bulletin*, December 1962
Collection: Yale University Art Gallery (gift of Iola S.
Haverstick)

102 Dorset Green

Oil on masonite
Exhibited: Catherine Viviano, New York, 1959 (12)
Collection: Walter Scott Goodhew

103 Dorset Ridge

Oil on masonite
Exhibited: Catherine Viviano, New York, 1959 (15)
Collection: George Deuble

104 Dry Wind *Plate 62*

Oil on masonite, 48 × 28
Exhibited: Catherine Viviano, New York, 1959 (11)
North American touring exhibition, 1959–60 (65),
illustrated in catalogue
Marion Koogler McNay Art Institute, San Antonio, 1963
Collection: Catherine Viviano

105 Gillan Creek

Oil on masonite, 48 × 36
Exhibited: Gimpel Fils, 1958 (4)
Collection: Joseph H. Hirshhorn

106 Green Coast

Oil on masonite, 72 × 48
Exhibited: Catherine Viviano, New York, 1959 (7)
Collection: Catherine Viviano

107 Green Place

Oil on masonite, 30 × 40
Collection: Dr Owen Franklin

108 Harvest Mile *Plate 66*

Oil on masonite, 48 × 72
Exhibited: Catherine Viviano, New York, 1959 (10)
Collection: Catherine Viviano

109 High Wind

Oil on masonite, 72 × 48
Exhibited: Catherine Viviano, New York, 1959 (4)
Collection: Gregory Smith

110 Ilfracombe

Oil on masonite, 48 × 30
Exhibited: Gimpel Fils, 1960 (14), illustrated in catalogue
Collection: Glyn Vivian Art Gallery, Swansea

111 Isle of Purbeck *Plate 23*

Oil on masonite, 48 × 72
Exhibited: Catherine Viviano, New York, 1959 (5)
Brandeis University, Massachusetts, Art on the Campus,
1959, illustrated in catalogue
Princeton University Art Museum, 1961 (101),
illustrated in catalogue in colour
Collection: Art Museum, Princeton University (gift of
Stanley J. Seeger Jr.)

112 Long Sea Surf

Oil on masonite, 72 × 48
Exhibited: Zurich, 1958 (27), illustrated in catalogue
Documenta 2, Kassel, 1959, illustrated in catalogue
British Council, 1960 (136)
Arts Council, 1968 (52)
Collection: Joseph H. Hirshhorn

113 Nemi

Oil on masonite, 48 × 50
Exhibited: Gimpel Fils, 1958 (9)
Collection: Lee Ault

114 Offshore Floating

Oil on masonite, 48 × 24
Exhibited: Gimpel Fils, 1958 (7)
Collection: E. R. Hosdell

115 Olive Wall

Oil on masonite, 30 × 21
Exhibited: Gimpel Fils, 1958 (6)
Illustrated: *Cimaise*, April–June, 1960
Collection: J. Peacock

116 Pink Mountain

Oil on masonite, 12 × 11
Exhibited: Gimpel Fils, 1958 (18)
Collection: Mrs J. Barry

117 St Ives Harbour

Oil on masonite, 34 × 48
Exhibited: Zurich, 1958 (27), illustrated in catalogue
Collection: E. H. Rauh

118 Saracinesco

Oil on masonite, 72 × 48
Exhibited: Gimpel Fils, 1958 (12)
Catherine Viviano, New York, 1959 (2)
Marion Koogler McNay Art Institute, San Antonio, 1963
Arts Council, 1968 (46)
Illustrated: *Bulletin of the Cleveland Museum of Art*,
October 1963
Collection: Cleveland Museum of Art

119 Surf Intruder

Oil on masonite, 49 × 48
Exhibited: Catherine Viviano, New York, 1959 (13)
Collection: Gregory Smith

120 Susan *Plate 35*

Oil on masonite, 47½ × 46
Exhibited: Catherine Viviano, New York, 1959 (16)
Princeton University Art Museum, 1960 (100),
illustrated in catalogue
Arts Council, 1968 (51)
Illustrated: *Art News*, September 1961
Collection: Stanley J. Seeger Jr.

121 Wheal Owles *Plate 31*

Oil on masonite, 48 × 72
Exhibited: Gimpel Fils, 1958 (13)
5th International Art Exhibition, Tokyo, 1959
British Council, 1960 (135)
Arts Council, 1968 (47)
Collection: Miss Mary Moore

122 Zennor Storm

Oil on masonite, 48 × 72
Exhibited: Catherine Viviano, New York, 1959 (9)
Marion Koogler McNay Art Institute, San Antonio, 1963
Collection: Catherine Viviano

1959

123 Dry Grass

Oil on canvas, 72 × 30
Exhibited: Arts Council, 1968 (54)
Collection: Ferens Art Gallery, Kingston upon Hull

124 Gunwalloe *Plate 41*

Oil on canvas, 60 × 72
Exhibited: São Paulo Biennale, 1961 (3), illustrated in
catalogue
Arts Council, 1968 (55)
Illustrated: *Cimaise*, April–June 1960
Collection: Mrs J. D. Priestman

125 High Tide

Oil on canvas, 72 × 60
Gimpel Fils, 1960 (1), illustrated in catalogue in colour
São Paulo Biennale, 1961 (4)
Arts Council, 1968 (56)
Collection: Basil Jacobs Fine Art Ltd

126 Low Tide *Plate 68*

Oil on canvas, 60 × 31
Exhibited: Gimpel Fils, 1960 (2)
International Art Exhibition, Tunis, 1961
Portugal, 1962 (68)
Canada, 1963–4 (26)
Tate Gallery, 1968 (57)
Collection: British Council

127 Offshore *Plate 39*

Oil on canvas, 60 × 72
Exhibited: 2nd John Moores Exhibition, Liverpool, 1959
(141); (2nd prize, British painters section)
Tate Gallery, 1964 (210), illustrated in catalogue
Arts Council, 1968 (53), illustrated in catalogue
Illustrated: *Cimaise*, April–June 1960, in colour
Architectural Review, March 1960
Collection: City Museum and Art Gallery, Birmingham

128 Rising Wind

Oil on masonite, 72 × 48
Exhibited: Documenta 2, Kassel, 1959
Gimpel Fils, 1960 (8)
Canada, 1963–4 (25)
Collection: Gulbenkian Foundation, Lisbon

129 Shy Deep

Oil on canvas, 60 × 60
Exhibited: Gimpel Fils, 1960 (3)
São Paulo Biennale, 1961 (2)
Collection: Dr Alastair Hunter

130 Tall Coast

Oil on canvas, 72 × 30
Exhibited: Gimpel Fils, 1960 (9)
São Paulo Biennale, 1961 (6), illustrated in catalogue
Collection: Narodni Gallery, Prague

1960

**131 The Conflict of Man with
the Tides and Sands** *Plate 40*

Mural on 750 6-inch white tiles for the Civil Engineering
Building, **University of Liverpool** (architect: Maxwell Fry),
28 feet × 9 feet 10 inches
A gouache sketch for the project was exhibited in Mural
Art Today, Victoria and Albert Museum, October 1960,
and in a travelling exhibition of the Mural Painters'
Society, 1961
Illustrated: *Quadrum* 10, 1961
Cornish Magazine, April 1962

132 Cross Country

Oil on canvas, 60 × 72
Exhibited: Gimpel Fils, 1960 (22)
Kompas 2, Eindhoven, 1962 (48), illustrated in catalogue
Arts Council, 1963 (5)
Collection: Private – Cornwall

133 Downwind

Oil on canvas, 72 × 30
Exhibited: Gimpel Fils, 1960 (12)
Collection: Estate of Tom Slick

134 Landfall

Oil on masonite, 12 × 7
Exhibited: Gimpel Fils, 1960 (18)
Collection: Private – London

135 Long Moor *Plate 34*

Oil on canvas, 60 × 60
Exhibited: Arthur Tooth & Son, 1960 (27)
Gimpel Fils, 1960 (5)
São Paulo Biennale, 1961 (5)
Arts Council, 1963 (3)
Arts Council, 1968 (59)
Collection: Basil Jacobs Fine Art Ltd.

136 Lost Mine *Plate 45*

Oil on canvas, 72 × 60
Exhibited: Gimpel Fils, 1960 (6), illustrated in catalogue
in colour
São Paulo Biennale, 1961 (7)
San Francisco, 1962 (54), illustrated in catalogue
Profile 3, Bochum, 1964 (92), illustrated in catalogue
Gimpel and Hanover Galerie, Zurich, 1964 (1),
illustrated in catalogue
Arts Council, 1965 (122)
Collection: Gimpel Fils

137 Lost Shore

Oil on canvas, 54 × 48
Exhibited: Gimpel Fils, 1960 (10)
Collection: Sonia Harris

138 Rosewall *Plate 33*

Oil on canvas, 72 × 60
Exhibited: Arts Council, 1960–61 (33)
Tate Gallery, 1964 (211), illustrated in catalogue
Arts Council, 1968 (58)
Illustrated: *Connoisseur*, July 1964
Collection: Basil Jacobs Fine Art Ltd

139 Soaring Flight *Plate 43*

Oil on canvas, 60 × 60
Exhibited: Gimpel Fils, 1960 (13)
Arts Council, 1961 (27)
São Paulo Biennale, 1961 (8), illustrated in catalogue
in colour
Tate Gallery, 1963 (64)
Arts Council, 1968 (61)
Collection: Arts Council of Great Britain

140 Solo Flight *Plate 44*

Oil on masonite, 48 × 72
Exhibited: Gimpel Fils, 1960 (11), illustrated in catalogue
Arts Council, 1968 (60)
Illustrated: *Arts* (New York), December 1960
Studio, November 1962
Collection: Mr and Mrs Nicholas Fraser

141 Strange Coast

Oil on masonite, $36 \times 17\frac{1}{2}$
Exhibited: Gimpel Fils, 1960 (15)
Arts Council, 1963 (4)
Collection: Private – England

142 Thermal *Plate 67*

Oil on canvas, 72 × 60
Exhibited: Gimpel Fils, 1960 (7), illustrated in catalogue
Arts Council, 1968 (62)
Washington D.C., 1970 (15), illustrated in catalogue
Collection: Trustees of the Tate Gallery

143 Weathering

Oil on masonite, 12 × 7
Exhibited: Gimpel Fils, 1960 (16)
Collection: R. Wakefield

1961

144 Airscape

Oil on canvas, 48 × 72
Exhibited: Catherine Viviano, New York, 1962 (11)
Collection: Richard Brown Baker

145 Backing Wind

Oil on canvas, 48 × 60
Exhibited: Canada, 1963–4 (27)
British Council, 1965–6
British Council, 1968–9 (20)
Collection: British Council

146 Beach Girl *Plate 36*

Oil on canvas, 42 × 60
Exhibited: São Paulo Biennale, 1961 (11)
Gimpel Fils, 1962 (1)
Arts Council, 1965 (123)
Arts Council, 1968 (64)
Illustrated: *Studio*, November 1962
Collection: Sheila Lanyon

147 Black Wing

Oil on canvas, 48 × 36
Exhibited: British Council, 1963 (26)
British Council, 1965–6
Il Fiorino Exhibition, Florence, 1967
Collection: British Council

148 Blue Round Corner

Oil on canvas, 72 × 48
Exhibited: Catherine Viviano, New York, 1962 (12)
San Antonio Art Institute, Texas, 1963
Arts Council, 1968 (71)
Collection: Sheila Lanyon

149 Calm Air

Oil on canvas, 60 × 48
Exhibited: San Francisco, 1962 (53)
Arts Council, 1963 (6)
Gimpel and Hanover Galerie, Zurich, 1964 (4)
Arts Council, 1968 (73)
Illustrated: Cambridge *Daily News*, October 18, 1963
Collection: Gimpel Fils

150 Cliff Soaring

Oil on canvas, 60 × 48
Exhibited: Pittsburgh International, 1961 (214)
Collection: Arnold Matthews

151 Cliff Wind

Oil on canvas, 60 × 48
Exhibited: Catherine Viviano, New York, 1962 (5)
Collection: Drew Logan

152 Cloud

Oil on canvas, 48 × 60
Exhibited: Catherine Viviano, New York, 1962 (10),
illustrated on cover of catalogue
Marion Koogler McNay Art Institute, San Antonio, 1963
Collection: Ernesto Regalado

153 Deep Blue Coast

Oil on canvas, 48 × 30
Collection: Simon Askin

154 Drift *Plate 42*

Oil on canvas, 60 × 42
Exhibited: São Paulo Biennale, 1961 (9)
Tate Gallery, 1963 (63)
Arts Council, 1968 (63)
Illustrated: *Studio*, August 1965
Collection: Alan Bowness

155 Eastern Shore

Oil on canvas, 60 × 48
Exhibited: São Paulo Biennale, 1961 (10)
Kompas 2, Eindhoven, 1962 (49), illustrated in catalogue
Arts Council, 1963 (7)
Gimpel and Hanover Galerie, Zurich, 1964 (2)
Il Fiorino exhibition, Florence, 1968
Collection: Basil Jacobs Fine Art Ltd.

156 Farm Country

Oil on canvas, 72 × 48
Collection: Private – England

157 Fly Away

Oil on canvas, 48 × 72
Exhibited: Catherine Viviano, New York, 1962 (9)
Marion Koogler McNay Art Institute, San Antonio, 1963
Collection: Sheila Lanyon

158 Ginger Hill

Oil on canvas, 48 × 24
Exhibited: Catherine Viviano, New York, 1962 (3)
Marion Koogler McNay Art Institute, San Antonio, 1963
Collection: Private – London

159 Halsetown

Oil on canvas, 60 × 48
Exhibited: Catherine Viviano, New York, 1962 (6)
Collection: Mary Schofield

160 Haymaker

Oil on canvas, 72 × 48
Exhibited: Catherine Viviano, New York, 1962 (8)
Marion Koogler McNay Art Institute, San Antonio, 1963
Collection: Basil Jacobs Fine Art Ltd.

161 Headwind

Oil on canvas, 48 × 72
Exhibited: Catherine Viviano, New York, 1962 (4)
Collection: Frank Porter

162 Inshore

Oil on canvas, 25 × 30
Exhibited: Catherine Viviano, New York, 1962 (14)
Illustrated: *Painter and Sculptor*, autumn 1962
Collection: James Brown

163 Lea Grass

Oil on canvas, 30 × 48
Exhibited: Blair Laing Gallery, Toronto, 1962
British Council, 1963 (25)
British Council, 1965–6
Il Fiorino exhibition, Florence, 1967
British Council, 1968
Collection: British Council

164 North Cliff

Oil on canvas, 60 × 60
Exhibited: Catherine Viviano, New York, 1962 (7)
Collection: Lorin Hodges

165 Orpheus *Plate 46*

Oil on canvas, 60 × 60
Exhibited: São Paulo Biennale, 1961 (12)
Premio Marzotto European touring exhibition, 1962–3,
illustrated in catalogue in colour (the picture was given a
Marzotto Acquisition Award)
Arts Council, 1968 (67)
Illustrated: *Arts* (New York), November 1962
Art in America, winter 1962
Connoisseur, May 1963
Collection: Premio Marzotto Institution, Valdagno

166 Rising Air

Oil on canvas, 60 × 42
Exhibited: Gimpel and Hanover Galerie, Zurich, 1964 (3)
Illustrated: *Time* (Atlantic edition), August 18, 1961, in
colour
Studio, November 1962
Collection: Stanley Marcus

167 Salome

Oil on canvas, 60 × 48
Exhibited: Catherine Viviano, New York, 1962 (2)
Arts Council, 1968 (65)
Illustrated: *Studio*, November 1962
Collection: Stanley J. Seeger Jr.

168 Saracinesco *Plate 47*

Oil on canvas, 72 × 60
Exhibited: Gimpel Fils, 1962 (5), illustrated in catalogue
in colour
British Council, 1963–4 (28)
Arts Council, 1968 (68), illustrated in catalogue in colour
Collection: Basil Jacobs Fine Art Ltd

169 Sea Going

Oil on canvas, 60 × 48
Exhibited: Gimpel Fils, 1962 (4), illustrated in catalogue
in colour
Arts Council, 1968 (72)
Collection: Gimpel Fils

170 Still Air

Oil on canvas, 36 × 48
Exhibited: Catherine Viviano, New York, 1962 (13)
Arts Council, 1968 (70)
Collection: Sheila Lanyon

171 Two Birds

Oil on canvas, 48 × 60
Exhibited: Gimpel Fils, 1962 (3), illustrated in catalogue
in colour
Tate Gallery, 1963 (65)
Arts Council, 1968 (69)
Illustrated: *Painter and Sculptor*, autumn 1962
Collection: Gimpel Fils

172 Witness

Oil on canvas, 72 × 48
Exhibited: Catherine Viviano, New York, 1962 (1)
Marion Koogler McNay Art Institute, San Antonio, 1963
Illustrated: *Studio*, November 1962
Collection: Sheila Lanyon

1962

173 Antigone

Oil on canvas, 72 × 48
Exhibited: Newlyn Art Gallery, 1963
Collection: Private – London

174 Cloud Base *Plate 65*

Oil on canvas, 48 × 72
Exhibited: Gimpel Fils, 1962 (7)
Bristol, 1963 (15)
Düsseldorf, 1964
Arts Council, 1965, illustrated in catalogue
Il Fiorino exhibition, Florence, 1968
Camden Arts Centre, 1969 (47)
Collection: Basil Jacobs Fine Art Ltd.

175 Delaware River Mural

Oil on canvas, 304 × 42
Collection: Stanley J. Seeger Jr.

176 Godrevy Rock

Oil on canvas, 48 × 60
Exhibited: Gimpel Fils, 1962 (9), illustrated in catalogue
Illustrated: *Vingtième Siècle*, Christmas 1963
Collection: National Gallery of Canada, Ottawa

177 High Moor *Plate 50*

Oil on canvas, 72 × 60
Exhibited: Gimpel Fils, 1962 (17)
Arts Council, 1968 (79)
Illustrated: *Kunstwerk*, November–December, 1962
The Dyer Bequest, Bristol Art Gallery booklet, 1963
Collection: Friends of Bristol Art Gallery (Dyer Bequest)

178 Inshore Wind

Oil on canvas, 48 × 60
Exhibited: Gimpel Fils, 1962 (14), illustrated in catalogue
Stone Gallery, Newcastle upon Tyne, 1963
Gimpel and Hanover Galerie, Zurich, 1964 (10)
Arts Council, 1965 (124)
Collection: Gimpel Fils

179 Loe Bar *Plate 51*

 Oil on canvas, 48×72
 Exhibited: Gimpel Fils, 1962 (6)
 Bristol, 1963 (14)
 Gimpel and Hanover Galerie, Zurich, 1964 (5)
 Mappin Art Gallery, Sheffield, 1964–6
 Arts Council, 1968 (74)
 Collection: Basil Jacobs Fine Art Ltd.

180 Long Shore

 Oil on canvas, 72×48
 Exhibited: Premio Marzotto European touring exhibition,
 1962–3 (54)
 4th John Moores Exhibition, Liverpool, 1963 (50)
 Profile 3, Bochum, 1964 (93), illustrated in catalogue
 Gimpel and Hanover Galerie, Zurich, 1964 (8)
 Collection: Private – London

181 Portreath Watch

 Oil on canvas, 72×48
 Exhibited: Gimpel Fils, 1962 (11), illustrated in catalogue
 Profile 3, Bochum, 1964 (94)
 Gimpel and Hanover Galerie, Zurich, 1964 (7),
 illustrated in catalogue
 Collection: Sheila Lanyon

182 Red Sand

 Oil on canvas, 48×60
 Exhibited: Gimpel Fils, 1962 (8)
 Gimpel and Hanover Galerie, Zurich, 1964 (6)
 Illustrated: *Contemporary British Art*, by Herbert Read
 (1964 edition), pl. 39b
 Collection: Private

183 Sunday

 Oil on aluminium, 72×48
 Collection: Private – England

184 Thaw

 Oil on canvas, 72×48
 Exhibited: Gimpel Fils, 1962 (12)
 Arts Council, 1963 (8)
 Collection: Private – London

185 Two Close *Plate 49*

 Oil on canvas, 48×36
 Exhibited: Gimpel Fils, 1962 (10)
 Bristol, 1963 (16)
 Gimpel and Hanover Galerie, Zurich, 1964 (7), illustrated
 in catalogue in colour
 Arts Council, 1965 (119)
 Arts Council, 1968 (75)
 Illustrated: *Studio*, August 1965, in colour
 Collection: Gimpel Fils

186 Two Place *Plate 48*

Oil on canvas, 72 × 50
Exhibited: Gimpel Fils, 1962 (13), illustrated in catalogue
Commonwealth Institute, 1963 (91)
Arts Council, 1968 (76), illustrated in catalogue in colour
Illustrated: *Vingtième Siècle*, Christmas 1963
Studio, August 1965
Collection: Basil Jacobs Fine Art Ltd.

1963

**187 Birmingham University, mural for
the Faculty of Arts Building** *Plate 52*

Oil on blockboard panels, 9 feet 6 inches × 16 feet (at the bottom), 20 feet (at the top)
Illustrated: *Daily Telegraph*, November 14, 1963

188 Black Day

Oil on canvas, 48 × 72
Exhibited: Arts Council, 1968 (84)
Collection: Sheila Lanyon

189 Blue Day

Oil on canvas, 20 × 24
Exhibited: Catherine Viviano, New York, 1964 (3)
Collection: Basil Jacobs Fine Art Ltd.

190 Eagle Pass *Plate 54*

Oil on canvas, 48 × 36
Exhibited: Gimpel and Hanover Galerie, Zurich, 1964 (13)
Arts Council, 1968 (81)
Illustrated: *Private View*, 1965, p.74 in colour
Collection: Gimpel Fils

191 Farm *Plate 53*

Oil on canvas, 42 × 60
Exhibited: Catherine Viviano, New York, 1964 (7)
Collection: Sheila Lanyon

192 Gunwalloe Church Cove

Oil on canvas, 60 × 72
Exhibited: Newlyn Art Gallery, summer 1965
Collection: Sheila Lanyon

193 Heather Coast

Oil on canvas, 48 × 60
Collection: Margaret Gardiner

194 Mexico

Oil on canvas, 36 × 48
Exhibited: Arts Council, 1968 (8c)
Washington D.C., 1970 (16),
illustrated in catalogue
Collection: Arts Council of Great Britain

195 North East *Plate 55*
Oil on canvas, 72 × 48
Exhibited: Catherine Viviano, New York, 1964 (2)
Arts Council, 1968 (83)
Collection: Basil Jacobs Fine Art Ltd.

196 Pony
Oil on canvas, 48 × 36
Exhibited: Gimpel and Hanover Galerie, Zurich, 1964 (11),
illustrated in catalogue
Collection: Gimpel Fils

197 Saltillo
Oil on canvas, 48 × 36
Exhibited: Arts Council, 1968 (82)
Collection: Gimpel Fils

198 Shore Weed
Oil on canvas, 20 × 16
Exhibited: Sheviock Gallery, Torpoint, 1970 (19)
Collection: Private – Cornwall

199 Texan
Oil on canvas, 72 × 48
Exhibited: Catherine Viviano, New York, 1964 (10)
Collection: Sheila Lanyon

200 Texan Landscape
Oil and paper on canvas, 25 × 31
Collection: Private – England

201 Wreck
Oil on canvas, 48 × 72
Exhibited: Tate Gallery, 1964 (212), illustrated in
catalogue
Gimpel and Hanover Galerie, Zurich, 1964 (12)
Tate Gallery, 1967 (25), illustrated in catalogue
Collection: Peter Stuyvesant Foundation, London

1964

202 Autumn
Oil and painted card on canvas, 48 × 60
Possibly unfinished
Exhibited: Arts Council, 1968 (95)
Collection: Private – London

203 Blue and Green
Oil on canvas, 36 × 48
Unfinished
Collection: Private – London

204 Clevedon Eurydice
Oil and polystyrene on canvas, 36 × 48
Exhibited: Bristol, 1970 (16)
Exeter, 1971 (25)
Collection: Sheila Lanyon

205 Clevedon Bandstand *Plate 58*

Oil on canvas, 48 × 72
Exhibited: Gimpel and Hanover Galerie, Zurich, 1964 (15)
Arts Council, 1965 (125)
Arts Council, 1968 (90), illustrated in catalogue in colour
Bristol, 1970 (14)
Collection: Sheila Lanyon

206 Clevedon Lake *Plate 57*

Oil on canvas, 48 × 36
Exhibited: Gimpel and Hanover Galerie, Zurich, 1964 (15),
illustrated in catalogue
Arts Council, 1968 (91)
Bristol, 1970 (17)
Exeter, 1971 (26)
Collection: Basil Jacobs Fine Art Ltd.

207 Clevedon Night *Plate 56*

Oil and polystyrene on canvas, 72 × 48
Exhibited: Bristol, 1970 (15)
Collection: Sheila Lanyon

208 Climb Out

Oil on canvas, plastic and wood collage, 48 × 72
Collection: Sheila Lanyon

209 Countryman

Oil on canvas with polystyrene collage, 72 × 48
Collection: Sheila Lanyon

210 Fistral *Plate 60*

Oil, pva, and plastic collage on canvas, 60 × 48
Exhibited: Gimpel and Hanover Galerie, Zurich, 1964 (17)
Arts Council, 1968 (92)
Illustrated: *London Magazine*, May 1968
Collection: Sheila Lanyon

211 Flying Grass

Oil on canvas, 16 × 20
Exhibited: Catherine Viviano, New York, 1964 (9)
Collection: Basil Jacobs Fine Art Ltd.

212 Glide Path *Plate 59*

Oil and plastic collage on canvas, 60 × 48
Exhibited: Gimpel and Hanover Galerie, Zurich, 1964 (18)
Arts Council, 1965 (126)
Arts Council, 1968 (93)
Illustrated: *London Magazine*, May 1968
Collection: Basil Jacobs Fine Art Ltd.

213 Lake

Oil on canvas, 48 × 72
Exhibited: Pittsburgh International, 1964 (251)
Catherine Viviano, New York, 1964 (5)
Collection: Sheila Lanyon

214 Lomnica (Marica)

Oil on canvas, 72 × 48
Exhibited: Catherine Viviano, New York, 1964 (4)
Arts Council, 1968 (88)
Collection: Basil Jacobs Fine Art Ltd.

215 Near Cloud

Oil on canvas, 48 × 60
Exhibited: Gimpel and Hanover Galerie, Zurich, 1964 (14)
Arts Council, 1968 (94)
Collection: Sheila Lanyon

216 Spring Coast (Perfumed Garden)

Oil on canvas, 48 × 60
Exhibited: Catherine Viviano, New York, 1964 (6)
Arts Council, 1968 (89)
Collection: Sheila Lanyon

217 Tatra

Oil on canvas, 36 × 48
Exhibited: Catherine Viviano, New York, 1964 (8)
Arts Council, 1968 (87), illustrated in catalogue
Collection: Basil Jacobs Fine Art Ltd.